GIOTTO

MARIO BUCCI

THAMES AND HUDSON

Translated from the Italian by Caroline Beamish

This edition © 1968 Thames and Hudson Ltd, London
Copyright © 1967 by Sadea Editore, Firenze

Published in the United States in 1989 by Thames and Hudson Inc.,
500 Fifth Avenue, New York, New York 10110

Library of Congress Catalog Card Number 89-50719

Printed in Italy

Life

' The birth of this great man took place in the year 1276, fourteen miles from Florence, in the town of Vespignano, his father, who was a simple field labourer, being named Bondone. ' Thus Vasari begins his life of Giotto. Later, when had reached the age of ten years, ' ... Bondone set him to watch a few sheep, and while he was following these from place to place to find pasture, he was always drawing something from Nature or representing the fancies which came into his head, on flat stones on the ground or on sand, so much was he attracted to the art of design by his natural inclination. Thus one day, when Cimabue was going on some business from Florence to Vespignano he came upon Giotto, who, while his sheep were grazing, was drawing one of them from life with a roughly pointed piece of stone upon a smooth surface of rock... Cimabue stopped in amazement and asked the boy if he would like to come and stay with him. ' Thus runs the legend adapted by Vasari from a story written earlier in the fifteenth century which was taken from the writer known as Anonimo Gaddiano and from Ghiberti. The information that we possess about Giotto, from documentary sources, is very slight; he was probably born in 1267 and died in Florence in 1337, laden with esteem and wealth earned during the course of a hard-working life.

Giotto spent his earliest apprenticeship in the studio of a painter in Florence, where his family was probably living at the time. The painter in question may have been Cimabue; at all events Giotto made a journey to Rome in about 1280, quite probably with Cimabue. From the turbulent atmosphere of Rome he moved to Assisi, at that time the most important centre of painting in Italy, far more vital than either Florence or Rome. Here he came into contact with two violently differing styles: the painting of the thirteenth century, as represented by Cimabue or the Maestro di San Francesco, who painted the earliest known cycle of the story of St Francis in the Lower Church of San

Francesco at Assisi, and the latest innovations of the four-teenth century, including the development of spatial depth and gothic fluidity of line. Giotto's frescoes in the basilica of San Francesco were exciting examples of the new style, and after his departure from Assisi echoes of his painting were to be found in the works of all his successors. In 1300 he was in Rome painting frescoes in San Giovanni in Laterano; only a tiny fragment of these, from the Loggia delle Benedizioni, survives and this is in extremely bad condition. From about 1304-8, possibly earlier, he was in Padua painting frescoes (now lost) in the Chiesa del Santo, and he also painted the cycle in the Arena Chapel at that time, as we learn from a fourteenth-century source: Ricco-baldo Ferrarese made a note of Giotto's activity in a chronicle dated 1312, only a short while after he had com-pleted the frescoes. Next he moved to Rimini where he painted frescoes in the church of San Francesco, now known as the Tempio Malatestiano, all of which have disappeared with the exception of one great *Crucifix*. The years from 1318 to 1328 he spent in Florence decorating the Peruzzi and the Bardi chapels in Santa Croce, and painting panel paintings, some of which survive scattered throughout the museums of the world. In 1328 he was summoned to Naples by Robert of Anjou, but none of the work he did there remains. In 1334 he was nominated master builder of the Cathedral church of Santa Maria del Fiore in Flor-ence, and architect of the city walls and fortifications; also in this year the bell-tower which is to this day associated with his name was begun. In 1335-6 he apparently did some painting in Milan, commissioned by Azzone Visconti (Vil-lani mentions this). On 8 January 1337 he died in Florence with his sorrowing wife, Ciuta, at his side, and mourned by ' all his fellow-citizens, and all those who had known him or even heard his name ', as Vasari says. ' He was buried in Santa Maria del Fiore, on the left hand as one enters the church, where a white marble slab is set up to the memory of this great man. '

Giotto's private life was that of a typical citizen of the city of Florence in the late thirteenth and early fourteenth century. In his business relationships, whether with his

fellow-citizens, with the clergy, the Roman Curia, the religious orders, or with the rich and powerful men of his day he played the part of a successful bourgeois; he was a countryman who had come to town and prospered, and he retained all the shrewdness and practical attachment to tangible things which country people have.

We must picture him in Florence as it then was, at a time of economic boom, a town swarming with wool and cloth merchants, industrialists, businessmen and bankers, the most important centre of trade and commerce in the whole of Europe; Dante criticized Florence in the harshest terms for this mercantile splendour, and dreamed of reviving the old country town with its wholesome, time-honoured ways.

Dante and Giotto: the names have been linked in a spurious juxtaposition for so many years that the real character of each has been romanticized beyond recognition. Dante, banished and in exile, is the classic *laudator temporis acti,* motivated by the loathing of the upper-class conservative for the new rich class, for the unscrupulous businessmen and the pushing industrialists who came to the fore in Florence during the later part of his life. He refused to recognize, let alone to appreciate, the remarkable social and economic development that was taking place in the city of his birth. Giotto, on the other hand, was never concerned with moral problems such as these. He wisely accepted the course his life took, compromising where necessary, making use of the things that came his way and generally keeping in step with his times; he would always be on the side of the stronger or wealthier party, whether it were the Commune of Florence or the Roman Curia, the fashionable monastic order, the order currently supported by the Pope, or the wealthy Lord of Padua, Enrico Scrovegni, whose father, a famous usurer, had already been condemned by Dante to eternal damnation in his *Inferno*, or the king of Naples, Azzone Visconti, Lord of Milan, or the richest moneylenders in Florence, the Bardi and Peruzzi families, who were bankers to the Pope and the king of England.

Giotto was extremely clear-headed and careful, a brilliant organizer of himself and his team, quite possibly greedy for money, almost certainly a usurer as he used to hire out

looms to small weaving businesses, bringing action against his debtors if they did not pay up with interest. Villani, Giotto's contemporary, has left a description of him as a highly educated and extremely cultivated person yet at the same time a man hungry for fame and riches. In the *Lives*, Vasari says: ' Giotto thus richly deserved the reward of 600 gold ducats which the delighted Pope gave to him, bestowing many other favours upon him, so that it became the talk of all Italy... When he at length received his dismissal (from Pope Clement V) he was sent away kindly with many gifts, so that he returned home no less rich than honoured and famous... Piero Saccone was a great admirer of Giotto's worth... When Giotto learned that he was wanted by so popular and famous a king (Robert of Anjou) he departed to serve him with the greatest alacrity. '

Giotto is the antithesis of Dante, that upright, incorruptible representative of the old world, and even though they were probably acquainted with one another, Giotto remained a man of his times, a member of an expanding society looking forward to a secure and comfortable future. He was one of the first painters to be paid properly and to earn the same respect as a man of letters or a poet; in fact he was one of the earliest artists to lead a life worthy of a man of the Renaissance. And his patrons, the rich, the powerful bankers and princes played the same part in his life as the *Signori* were to play in the artistic life of the fifteenth century. The progress of his life displayed a freedom and clear-sightedness which are typical of the Tuscan personality and typical of the Florentines during that period of tremendous development, before the days of the Medicis. Giotto reminds one in some ways of Marco Datini, the merchant of Prato who was a prominent figure of the following century; yet for all his bourgeois behaviour, he painted as no-one had painted before.

Works

Imagine Giotto's first entry into the basilica of S. Francesco in Assisi; the huge nave, with its sweeping modern lines, had been finished only forty years earlier (the church was consecrated in 1253) and it still must have looked something like a shipyard, cluttered with beams and scaffolding, the decoration only half finished, its colour apparently suspended in a void amid so much whiteness.

The church had been built in its entirety over a period of only twenty-five years. The sturdy, dark Lower Church with its low Romanesque arches, its flickering candles round the tomb of St Francis, is built into the solid rock of his native hillside, casting a mysterious, magical light. The upper Church, built on to the Lower as if it had grown from it quite naturally, is in the vigorous new Italian Gothic style; inside it is all space and light, the brightness tempered only by the stained glass, some of the most beautiful (and neglected) of the period.

The date of Giotto's arrival in Assisi for his first really important commission has been debated at length by scholars all over the world, particularly during the last thirty years. The dates of the different frescoes are also most uncertain. The question of which ones are really by Giotto and which by other painters who worked with him, or assistants, or collaborators working under his direction is still a subject of speculation and research. I shall follow the most recent and reliable conclusions, those generally accepted by the greatest number of art historians, particularly in Italy. The year in which he began his work in the basilica at Assisi was probably 1290, when he was about twenty-five years old, or slightly less, with at least five years' work behind him. One may suppose that he had already given proof of his talent before his arrival in Assisi, and that he arrived there with a certain reputation.

The decoration of the church had probably been started approximately in 1278, twenty-five years after its consecration, by one of the best known artists of the time, Gio-

vanni Cimabue. The first painting in the basilica, in the Lower Church, was most probably the great *Crucifix*, dated 1236 and now lost, which was commissioned from Giunta Pisano, one of the chief glories of the previous generation of painters; the two orders, Franciscans and Dominicans, had fought for possession of this painting throughout the third and fourth decades of the previous century. But although Giotto's apprenticeship with Cimabue has been confidently accepted for so long, the master's influence is extremely hard to detect in the few paintings that remain today by the young Giotto. It should be emphasized however, that none of these dates from his very early youth, our knowledge of the paintings of Giotto begins only from the paintings he worked on during his stay in Assisi, and includes panels painted at about that time, all of which clearly state an artistic position half way between Rome and Assisi with brief references to the work of those Sienese painters which Giotto had encountered in the Basilica of San Francesco between 1290 and 1292.

Nothing remains, or rather nothing has yet been found, belonging to the twenty years of Giotto's youth, unless one agrees with the theory that he collaborated in the mosaics in the Baptistery in Florence; if this is so he would have been employed at the very end of a long series of artists (as Longhi points out) who had been tackling the work in turn throughout the previous two generations, beginning with the friar Iacopo Francescano, who had covered the first barrel vault with mosaic in 1228. This early experience of the manual tradition of mosaic in the Baptistery could be a key to the subsequent course of his career, or at any rate a preparation for his journey to Rome; one can find a definite echo of the feeling of the Florentine mosaics in the painted scenes at Assisi, especially in the two stories of Isaac. For us today these two stories represent Giotto's artistic baptism, but for the Franciscans and the Roman Curia who were in charge of the work at Assisi they were the proof that Giotto was the right person to have chosen for the job. Obviously this was the conclusion they reached, as Giotto was then commissioned to continue with other frescoes.

The classical feeling that persisted in Florentine Romanesque architecture, in for example the elegant church of San Miniato al Monte and the handsome San Giovanni, seems to bring us very close to the Renaissance and the architecture of Brunelleschi, with its clarity and geometric proportion, logically and rhythmically worked out; the young Giotto must have longed to inspect the prototype of all classical harmony and style in Rome. Though he expressed himself in paint, Giotto was so much of a born architect that even his figures have an architectural quality about them, and he was also so near to being a sculptor that his figures and scenes from nature appear to have been carved out of some stony, resistent material. He must have treasured the lessons of Nicola Pisano, the sculptor, much more than any of the technical teaching he had received from the painters who were his contemporaries, even perhaps from Cimabue himself. Pisano had absorbed the spirit of the sculpture of the classical world. Another sculptor who must have had some influence on Giotto was Arnolfo di Cambio, also a Florentine, in Rome from 1276, working on the Annibaldi monument, then in Orvieto carving the tomb of Cardinal de Braye (1283), then on Roman soil again making the two ciboria, the San Paolo ciborium dated 1285 and the one in Santa Maria in Trastevere, dated 1293, which was contemporary with Giotto's first frescoes at Assisi. Arnolfo di Cambio is the only figure amongst Giotto's contemporaries whose work bears comparison with Giotto's.

Echoes of Arnolfo di Cambio have been discovered in all the buildings portrayed in Giotto's Assisi cycle; and Gioseffi has pointed out various possible connections with the 'third style' (to be found amongst the Roman ruins) in the development of perspective; the iconography does not however stop there. One can work backwards and find connections with the oldest mosaics in Santa Maria Maggiore, with scenes from the life of Moses dating from the fourth century, with the great font in the apse of Santa Pudenziana which shows Christ seated in an architectural framework, impressive because of its suggestion of space and atmosphere, the perfection of its rhythm, and the harmony of the groups and figures against a background which itself

retains to a large extent the classical spirit.

A disturbing, almost overpowering humanity stands out from the frescoes in the transept at Assisi, where Cimabue had painted the vaulting with pictures of the Evangelists, huge figures which seem to be hewn from the rock, towering over entire cities tucked away in each small segment of the roof. The walls of the transept are decorated with cycles of the Passion, the Life of the Virgin and St Peter and the Apocalypse. If one studies these sublime visions, the crowd at the feet of Christ in the *Crucifixion*, beneath a sky furrowed by random flights of angels, it becomes obvious that the last great expressionist of the Romanesque period painted on these walls a world completely out of proportion to the scale of the architecture; the frescoes seem to attack the walls and completely fail to become part of the plain, beautifully proportioned nave. Cimabue probably worked in Assisi from about 1278 or 1280 until about 1285; then, in the following years, the fourth arch, including the roof and the first two cycles of the third, the *Creation of Eve* and the *Garden of Eden*, were painted by Roman painters under the guidance of Cimabue. At first the older painter's influence was very strong, then it dwindled away almost completely. Later two Tuscan painters arrived to decorate the ceilings of the second and third sections, Duccio with a *Crucifixion* and the *Ride to Calvary*, and Giotto with the first two scenes of the story of Isaac. These two magnificent paintings were painted as a kind of proof of excellence, singlehanded and with the greatest possible care and attention; the two that followed immediately, the *Resurrection* and the *Mourning for the Dead Christ* contain references to sculpture and paintings of antiquity, both Roman and Hellenistic, filtered through the classical interpretations of Torriti or Cavallini – Cavallini was probably in this case the main influence. Giotto's re-interpretation of the classical tradition is however in utterly unacademic terms, even though his work is mature and restrained: he has revitalized the tradition with his own brand of realism and poetry. Giotto's humanism, his anticipation of the personality of the Renaissance and his expression of it in his painting appear much more markedly in the subsequent *Story of St Francis*. The

humanity which had been arrested and, as it were, elegantly embalmed in the desiccated and stereotyped cyphers of paintings in the byzantine style; which had appeared in gigantically oppressive form in the irregular smoky bronze of Coppo's *Christs*, teeming in the little histories; or frantic, distorted and afraid in Cimabue's figures: this humanity was now expressed in classical cadences and broad rhythms in the panels depicting the story of Isaac, reminiscent of the Etruscan sarcophagus-covers in their subterranean tombs. In Giotto humanity, recovering from its long, barbaric Oriental slumber, returned gradually to a rediscovery of its true self, and released itself from the bonds which held it back in the ' form ' of the symbol and in the fixed and schematic mould of the ' type '. It returned to a representation of itself in the realization of personal sorrow, of courage, of a faith neither over-stressed nor suppressed, but serene and confident of its own dignity (*pls 1-3*).

Only two paintings on panels have come down to us from this period of work in Assisi; each clearly demonstrates the same search for the third dimension, as well as that humanity and poetic realism which raise these paintings above the slavish adherence to tradition. They are the *Virgin and Child* in the church of San Giorgio alla Costa (*pl. 4*) and the *Crucifix* in Santa Maria Novella in Florence. The Madonna is seated on a heavy throne of the type favoured by Arnolfo di Cambio, and she and her Child are squarely placed in what might be a block carved by Arnolfo. There is none of the old fashioned gilding that would have transformed her body into a glittering mantle, with no form or skeleton to hold it up, nor is she apotheosized in some supernatural element; she is built up from within as well as without, a very simple and realistic female portrait which may even seem too straightforward, yet which represents an important departure from old ideas. Giotto arrived at his pictorial concept of the Virgin Mary through original formal thinking. The ' Human Comedy ' which was the outcome of his thinking might very well be compared with Dante's Divine Comedy. The angels behind the throne, their hair parted into carefully arranged locks, the Child's robe with its box pleats and regular triangular folds – these tiny, rather

wooden details remind us (as we were reminded in the *Story of Isaac*) of Giotto's familiarity with mosaic work; reminiscent of mosaic too is the clear dark outline around each object according to some preordained and stylized design. We find the same drapery folds in the figures of the Madonna and St John, at each end of the horizontal bar of the great *Crucifix* in Santa Maria Novella (*pls 5-7*), before which it was ordained that the lamp of Ricuccio del fù Puccio del Mugnaio should burn for ever. The body of the crucified Jesus is here the body of a man suffering a slow, realistic agony, not the brilliant enamelled manikin of the thirteenth century, triumphing over death with his empty eyes wide open, nor the terrifying, slightly sadistic image which was sometimes used as a symbol in earlier times. This Christ is the first modern Christ to be portrayed; the man on the cross is one of us, a human being who suffers.

After the classic beauty of Esau, who looks as if he had been taken straight from the walls of the Villa dei Misteri in Pompeii (he and Isaac are robed in light, geometrically pleated garments like Ionic statues), and after the Ionic rhythms of the wonderful *Lamentation* in which Giotto reveals a good deal of his private vocabulary (the still figures have the same rigidity as the mountain, and the mourning arch formed around the body of Christ by the kneeling figures of Mary and St John seems to enfold the body in a tomb-like enclosure of embraces and glances exchanged), the contrast with the *Story of St Francis* does not seem so marked as some people have implied it to be. If there is a contrast it is completely intentional, intended to make clear the enormous difference between the Bible, a 'classical' religious document which would remain in popular memory in a constant form, and the legend of St Francis; the saint belonged to the present day, indeed some of the older brethren in the convent could remember seeing him.

For the ceiling of the first section of the nave, which was to be decorated with the *Doctors of the Church*, Giotto painted perspective portraits, very foreshortened at the base and elongated above; eight intricate thrones and eight lecterns. The rich ornament is Roman: inlaid wood, canopies, barley-sugar columns, all on a very large scale thanks

12

to the effects of foreshortening and the disproportionately broad base of the triangle each one occupies.

After such Roman richness and ostentation (there is not a trace of Byzantine influence here, as Giotto's style is still full of the kaleidoscopic impressions left by the innumerable ancient and modern basilicas of Rome), he was faced with the two long walls of the nave, still white and undecorated in their lower section, which was built to protrude slightly beyond the level of the walls and thus presented a marvellous opportunity for the perspective creation of space into the thickness of the walls. Giotto conceived his design as a series of scenes side by side, divided by narrow twisted columns and linked by an architrave from one end to the other, with a cornice underneath surmounting corbels realistically painted in full perspective. This architectural framework, with its attempt at *trompe-l'œil*, was borrowed from the Third Style of Roman painting.

The twenty-eight panels retell the legend of St Francis as told by St Bonaventure (1260-3), and were painted from the right hand wall of the transept along to the main door and then along the left hand wall. It is presumed that they were painted in slightly over two years and although each panel reflects something of Giotto's influence, by no means all attain the same high quality. Giotto had various assistants with him, including the Sienese Memmo di Filippuccio (father of Filippo Memmi), as Giovanni Previtali has recently shown, and alto the Master of St Cecilia who was one of the most valuable of his collaborators; Previtali, in his *Maestro del Crocifisso di Montefalco*, has demonstrated how easily recognizable is the hand of the Master of St Cecilia. Giotto worked with a large number of assistants in an attempt to finish the enormous amount of work in as short a time as possible, quite probably in only two years (*pls 8-31*).

In the scene showing *St Francis giving his mantle to a poor knight* (*pls 8-9*), the earliest of the cycle, Giotto's new vocabulary is already in use, and with none of the toning-down that we find later in Padua. The two small hills with the higher, more solid hills behind, one bearing the city on its summit and the other the convent, painted in accurate perspective against the brilliantly coloured sky, meet

where the saint is standing and his figure fills the valley between them, like a river. The shape of the horse echoes the curve of the hillside and the bowing figure of the poor man paying homage to the saint. In *St Francis renouncing the world* (*pls 12-14*) the two groups on the right and left of the fresco confront one another and the façades of the buildings behind correspond to the parties they represent, the rich townspeople on one side led by St Francis' father, and the saint with a few members of the clergy on the other. In the empty space between the two groups, which is there to lay emphasis on the gap which divides these two worlds, the hands of St Francis are raised in supplication towards the source of his faith, the hand of God appearing in the sky. The walls and buildings in the *Expulsion of the demons* (*pls 20-1*) are those of the city of Arezzo; they are piled up in a patchwork of colours and textures to give the maximum illusion of space to the small area they occupy. The careful juxtaposition of the two buildings in the *Ordeal by fire* throws the handiwork of Giotto's assistant who painted the figures into strong relief; the characters here are much flatter that any figures painted by Giotto himself. The enclosure in the *Miracle at Greccio* (*pls 22-3*) is marvellously conceived. A kind of ciborium in the style of Arnolfo di Cambio stands between the spectator and the enclosure wall to give some idea of the distance, and there is a foreshortened pulpit on the right. In the air a huge cross (shaped like Giotto's Santa Maria Novella *Crucifix*) painted red and seen from behind, is set at an angle over the space outside the church which we have to imagine as we cannot see it; Giotto deliberately restricted his view to the inside of the church in order that the spectator's whole attention should be concentrated on St Francis and the architecture immediately surrounding him. There are other scenes showing closed interiors, including the *Sanctioning of the Rule* (*pl. 16*), *St Francis preaching before Honorius III* (*pl. 29*) and the *Chapter at Arles*, and all are designed according to the strictest rules of perspective, with architectural care and method. At other times space, or simply the empty air with a few houses sketched against it, is used to give a vague feeling of scenery, generally the scenery of Umbria where

some of the scenes took place (the *Vision of the thrones pl. 19*, and the *Vision of the fiery chariot, pls 17-18*); all the spectator's attention is focussed on the characters in the foreground. In the *Vision of the fiery chariot* the horse is copied from the horses of the Dioscuri in Rome, and the chariot seems to be copied directly from a Roman bas-relief. The natural scenery and the houses are always an essential part of the atmosphere that Giotto is trying to create, and contribute strongly to the drama or to the relationships between the characters. A good example of this is the cage of laths from which St Francis sees his *Vision of the palace and arms*; the cage stands alongside the ornate red and white palace which, although its dimensions are tiny and therefore dreamlike, looks absolutely real and convincing and is deliberately isolated in an empty space.

How dry and crumbling the rocks in the *Miracle of the spring (pls 24-5)* appear! The rocky pyramid on the right points upwards in the same gesture as St Francis' praying hands, and its base curves round to form a natural cove for the well-known figure of the thirsty traveller. This figure is a softer, attenuated version of figures of drinkers by Arnolfo di Cambio, yet it is just as powerful. In the *Death of the Knight of Celano (pls 27-8)*, the curved wall with the balcony above acts as a frame for St Francis and sets him apart from the faceless crowd thronging round the dying ·figure; the drama of his intervention is given its full value by his splendid isolation, and it is heightened by the white table in front of him, abandoned by the diners who are all crowding round the Knight of Celano; bread, pitchers of wine and cutlery are left in a still-life on the white tablecloth, like a painting by Morandi.

Very closely related to the Assisi cycle, and therefore datable to the close of the thirteenth century, is the panel which Giotto painted for the church of San Francesco in Pisa, in which there was already a painting by the mature Cimabue, the *Maestà* now in the Louvre. Giotto's painting shows St Francis receiving the stigmata and it is basically a repetition of the scene he painted in Assisi. With the utmost care and with exquisite use of colour and detail, he repeats three of the Assisi stories in much smaller versions; his

touch is no less sure here than when he enjoys the broad brush and the freedom of the fresco painter. The pillar of San Giovanni in Laterano in the *Dream* is much more delicate than the one in the fresco version and the painted tabernacle containing the Pope's bed is quite different, more diaphanous and elaborate, as befits something intended to be placed at eye-level on an altar, next to the real tabernacle, which would certainly be made of ornate gold or elegant marble. In the *Sanctioning of the Rule* the architecture in the background is no longer a vital part of the scenery, a carefully balanced frame for the drama that is taking place; it is a realistic reconstruction of a well-known place, with every detail included as in a Flemish painting. The two groups, the friars and the members of the Roman Curia, are painted with an attention to historical detail and an individuality which is often missing in the frescoes, where Giotto's collaborators tended to execute a scheme designed by their master; the result was bound to lack the personal touch that we find in the Pisa paintings. The tree in *St Francis preaching to the birds* is slenderer and more fragile than the Assisi tree (*pl. 26*), and the oak leaves against the pale gold background (more spacious seeming than the blue backdrop at Assisi) look as if they would rustle in the lightest breeze. The figure of St Francis, Gothic and elongated, echoes the shape of the tree and the configuration of birds in mid-air; the birds themselves give the measure of the space surrounding them, and are reminiscent of the birds painted over a hundred years later by Domenico Veneziano in the *Adoration* now in Berlin. The painted panel in the Louvre can be certainly linked with a small Virgin in the Ashmolean Museum, Oxford, both painted at the beginning of the fourteenth century; Volpe, who first connected these two works, said that in them Giotto ' revived the qualities of Pisano and Arnolfo di Cambio with the greatest subtlety ', and achieved the perfect synthesis of colour and form. The almost perfect condition of the paint gives us a very accurate idea of Giotto's use of tonal subtleties: the light falling on the mantle, across the shoulders and wrappings of the Infant Jesus gives a warmth and humanity to the Infant's gesture which could only have been

rivalled by some of the groups carved by Giovanni Pisano in Pisa a few years earlier; Giotto must have seen these, and was surely inspired by them. We find such delicate shading again in the much discussed *Badia Polyptych*, which has at last been definitively attributed to Giotto (Vasari said of it: 'It is by Giotto as is the high altar in the same chapel'). Its restoration confirms a theory held by Thode as far back as 1885 (*pls 32-3*). In spite of the bad state of repair it is clear that shading is used to soften the outlines of the figures, and we can still appreciate the elegance of the background detail, including the magical Kufic script. The centre of this polyptych, the *Virgin and Child*, is close to the Oxford one; the four accompanying saints stand out from their golden backgrounds with such tremendous vigour that only the Masaccio-like figures in the Pisa polyptych can compare with them. Besides his use of the technique of foreshortening, which was a great innovation, Giotto uses an impressive chiaroscuro technique, still visible through all the damage done to the paintings. Delicate touches such as the Virgin's veil allowing her ear to be seen through its gauzy folds, the absence of heavy drapery and an ornate headdress indicate that we are approaching Giotto's Padua period; this polyptych, with its elongated, refined angels and Gothic woodwork to match, is his farewell to his early period. Very closely linked to the Padua period and probably painted at the same time as the Arena frescoes (the fresco season lasted only through the dry months, and Giotto may have returned to the studio in Florence to paint panel paintings during the winter) is the *Ognissanti Madonna* (*pls 34-5*), now in the Uffizi where it hangs between the famous *Madonnas* of Cimabue and Duccio; they make a most interesting trio. The compact and powerful group of the Virgin and Child, placed under a fragile canopy which no longer bears the imprint of Cosma or Arnolfo di Cambio but is pure Gothic, is as exquisitely delicate as a reliquary finely wrought by a goldsmith. The Virgin is more refined than the Virgin of San Giorgio alla Costa, but nevertheless she remains homely and rustic; the square-headed Child is a picture of health and strength, as befits the mission which lies ahead of him. Giotto's Madonna is quite different from the dynam-

ic, virile lady, perched on a sumptuous throne like a co-
lossal idol, painted by Cimabue, or the elegant Hellenistic
figure by Duccio. He achieves some sort of balance be-
tween the physical and moral aspects of his subject, the
divine strength of his Madonna is expressed by her calm,
serene gaze and nothing more ostentatious or theatrical is
required. Her white dress and dark blue mantle edged
with gold, falling in folds around her body, are the simple
expression of her divinity. The magnificent angels gazing at
her are separated from her by her ornate throne; inside the
throne the scene is simple and human.

The fame of the Assisi frescoes must have spread very
rapidly, as in 1300 Giotto was summoned to Rome for the
Jubilee of Boniface VIII to decorate the Loggia in San Gio-
vanni in Laterano. The tiny fragment of this that remains,
has been cleaned, and confirms the view that it was painted
about the Assisi period; it is in a very poor state of pre-
servation and was probably painted with the assistance of
pupils. Very soon after this Giotto was in Padua, possibly
working on frescoes in the church of San Francesco.

Nothing remains in San Francesco that can be attributed to
Giotto, but in a church which was built outside the city of
Padua as it then was he left an extremely well-known cycle
illustrating stories of Joachim, St Anne and the Virgin Mary.
The man who commissioned this great new work was Enrico
Scrovegni, the most prominent citizen of Padua, who wanted
the chapel of his palace (built against the ruins of the Roman
Arena) to be the richest in all Padua. With the astuteness
of a Renaissance prince he hired the best-known name in
painting of the day. Giotto himself did not underestimate
the opportunity which was at last presented to him of paint-
ing a series of frescoes completely single-handed and with
absolute freedom, apart from the choice of subject: the
chapel was dedicated to the Annunciation and therefore the
life of the Virgin was the proper subject for the decoration
of the interior. It is also possible, as Gioseffi has recently
tried to show, that Giotto was the architect of the Arena
Chapel as well as the author of the frescoes. It was begun
in 1303, consecrated in 1305, it is thought before the fres-
coes were finished (in fact they were probably only just

begun), and the decoration was completed during the following two or three years, that is by about 1308. The architecture inside the building is almost non-existent, as Gioseffi has pointed out, the nave being rather like a tunnel; but this would be an excellent design for a painter who would want smooth walls and ceilings, with no decorative tracery, to allow the maximum space for his paintings. On such walls his painted architecture and decorations would be shown to their best advantage, his figures and scenes could tell their stories clearly and without interruption.

The Arena Chapel was built to replace an older and more modest church, in front of which miracle plays took place every year with the life of the Virgin Mary and the Annunciation in particular as their subject. It was quite natural that Giotto, always so interested in what was happening around him, should have seen the plays while he was preparing to paint the same scenes on the walls of the chapel then being built; he was a native of Florence, where there were certainly perfomances of the same type, and had recently spent some time in Umbria where the miracle play had its earliest beginnings. He must have appreciated the clarity of the narrative and the arrangement of the various scenes of the play, and also the importance of certain pieces of scenery in the unfolding of the drama; his work on the walls of the chapel is an enduring reflection of the annual performance and a kind of official record of it. It is worth remembering the background scenery in medieval carvings and miniatures, and the way in which different sceneries (such as a church or an enclosed room) were set down one beside the other in medieval religious drama; the actual setting of the drama would be suggested in a most perfunctory way by a single building, a tree or a piece of a mountain. Giotto was an architect, a designer of scenery and, as manipulator of characters and emotions, the ideal director of the dramas he depicted; his personages manage to achieve the maximum expression with the minimum display of effort, and their simple gestures have something tremendously modern about them.

The greatness of this cycle (*pls 36-53*) lies in the superb handling of character and scenery which mark Giotto's

maturity, his achievement of confidence in the handling of the materials at his disposal. Such solid, tangible figures and buildings are not to be found in any other narrative paintings painted around those years. Giotto's painted figures neither swell nor crumble in the damp, chalky plaster, made of sand, lime and coloured earth; the plaster appears to have set inside the dark outlines with which Giotto surrounds his figures, and the soft, shaded colours give a tremendous tactile quality to each figure, adding weight and substance to what would otherwise be flat. Every gesture, every face and hand has been submitted to the minutest inspection and consideration in order that it should be the expression of the essence, of the stuff of life itself, part of a carefully imposed time scheme and yet timeless and eternal, part of a spatial construction, yet limitless and unbounded. The rocky hillsides are set in a landscape which is constructed in their likeness: and the hills and little valleys echo the serenity or pain or wonder of the human figures in their midst, thus crystalline heights or weighty rocks complement the emotions of the human drama and achieve sublime, miraculous dignity. The sky overhead is pure, unbroken enamel blue, without the resonance or transparency of the real sky – it is a back-cloth which serves to throw the characters into relief and give the full value to buildings, houses and palaces, projecting them into the foreground in case they should be lost in space. From the earliest episodes in the *Story of Joachim (pls 36, 38-9)*, dedicated to the fundamental forms of nature, the perspective of each scene becomes progressively more complex, though the emotional focal point is always absolutely distinct. In the *Meeting at the Golden Gate (pls 40-1)* the two characters embracing on the left hand side form a Gothic arch at the corner of one of the two towers which form the gateway. Anna and her companions, coming out of the city through the gate, have an air of sophistication, almost of worldliness, which would have been unthinkable in the Assisi period; they are elegantly dressed with long blond plaits wound round their heads in the style which, even to this day, is typical of the Veneto. It is interesting that Giotto should have dressed them in modern dress; in fact he did this when-

ever possible, in order to give a vital and modern interpretation to stories which had almost acquired the status of myths. The cowed-looking woman in the black cloak is discreetly covering her face, and unconsciously creating a void between the elegant ladies and the Gothic embrace. This and other pieces of scenery occur in several stories, with different characters, as if to link the scenes in a continuous narrative.

In the *Annunciation to St Anne* (*pl. 37*) the figure of the maidservant outside the portico adds to the feeling of space around the central character. Attention is focussed on St Anne's chamber and Giotto has pruned away unwanted detail ruthlessly, leaving only the white hangings as scenery. The same room with its portico figures in the following scene, the *Birth of the Virgin Mary* (*pl. 42*), but this time it is filled with movement and life. Three scenes follow, the first, the *Consignment of the staves*, represents preparation, the second, *Prayer*, with the faithful saying their rosaries, represents the suspense of waiting and the third, the *Marriage of the Virgin* (*pl. 43*), is the final resolution and shows figures in a circle against the same background that we saw before, the little room and portico, but here it is seen from one corner and contains an altar. The silence of the second scene contrasts abruptly with the gay *Marriage of the Virgin*, where the atmosphere is that of a party; Mary's three companions are smirking at the guests like characters in a fresco by Giovanni da Milano. The grace with which the procession of figures is transformed into the nuptial procession reminds one of the perfect harmony of Piero della Francesca's *Procession of the Queen of Sheba* in Arezzo. Some figures are deliberately placed to draw the spectator's attention, framed in settings of their own; thus for instance the Virgin and the angel in the *Annunciation* (*pl. 44*), like two carved figures flanking the doorway of a church, occupy the sides of the great arch of the chapel which opens on to the apse. The apse itself is dominated by the superb marble *Virgin and Child*, by Giovanni Pisano, on the high altar. It is possible that Giotto intentionally painted his two figures separated by the columns of the tabernacle, against a dark background,

because he knew that they would thus stand out as clearly as possible. On this same wall, besides the *Annunciation* and the two tabernacles painted in perspective so that they converge towards the centre of the church, there is something strikingly original which Longhi was the first to notice: the two small chapels or choirs, which bear a very close resemblance to the two chapels in the transept of Santa Croce, beside the apse. The lower part of the two chapels is obscured by the church wall, but above the shallow parapet which is like a choir gallery there are two lateral arches which can be seen in perfect perspective from the centre of the church: and Longhi also noticed that the two small painted windows below are lighted from behind by the blue sky, and here the sky is not the painted backcloth that it is in the frescoes along the side walls, but the real sky, its transparent blue matching that seen through the big windows in the apse. Giotto was ' fully conscious of perspective. And it follows that if he did not use a wholly perspective method in the other narrative scenes this was absolutely intentional, as he wanted to paint a more limited world ' (Longhi).

The marvellous figure of the Madonna in the *Nativity* (*pl. 45*), leaning forward to embrace the Infant Jesus beneath the slender wooden roof, is the same person as the seated figure in the *Adoration of the Magi*; but as she welcomes the Three Kings, with her blond braided hair covered this time by her mantle, we seem to be witnessing a semi-official scene, whereas in the *Nativity* her mantle has fallen back and we are taking part in a familiar and intimate moment.

On the left hand side, the astonished-looking camel gives the *Adoration of the Magi* an Oriental flavour, though even the camel (which must be one of the first to appear in Western painting) has a human look about it. The procession of scenes which follows has a musical rhythm. The famous *Flight into Egypt* (*pl. 47*) is grave and dignified, the figures proceeding slowly forward as if pulled on wheels against the rocky background. Isolated in the centre the Madonna, staring towards the road ahead, makes a triangular shape, and the Child is part of the triangle; this shape is echoed

by the pyramidal mountain in which the little group is framed; it appears to be moving with them from left to right. The rhythm is syncopated and dramatic in the *Slaughter of the Innocents* (*pl. 48*); here movement abounds and the amount of expression is worthy of one of Giovanni Pisano's crowded bas-reliefs. The church in the background is reminiscent of San Francesco in Bologna, which Giotto probably saw during one of his journeys from Florence to Padua. Even more dramatic, though expressed with less violence, is the *Arrest of Jesus* (*pl. 50*); the great flourish of the cloak of the thirteenth apostle symbolises his falsehood and insincerity. The two faces are physically absolutely distinct, Christ's profile being serene and somewhat Grecian, Judas' bulbous and simian, a clear guide to his character. The heaving, rushing crowd and the scenery are repeated in a different situation in the *Entry into Jerusalem*; here the crowd is surging out of the great gate towards the cloth stretched beneath the hoofs of the donkey, and this surging movement dying away is repeated again by the rocky hillside slowly sloping away to nothing beside Christ's head in the tragic *Lamentation*; St John's outstretched arms and Christ's body seem to dam the flow of the hillside before it reaches Christ's head, stemming the onsurge of sadness and pain. Sadness and pain suffuse the groups of people in the foreground, seen from behind, and the silent, incommunicable suffering revives the memory of Dante's Paolo and Francesca. In the final scenes, the *Noli me tangere* and the *Ascension*, the body of Christ has become more diaphanous and unreal; his feet hardly seem to touch the ground beside the solid triangular figure of the Magdalene. Mary Magdalene comes to life through the simple, emotional gesture of her outstretched hand and her sharp, tragic profile; the sorrowful soldiers on the right, foreshortened from bottom to top, seem to anticipate the soldiers in Piero della Francesca's *Resurrection* in San Sepolcro, painted 150 years later.

Giotto's limitations, if he has any limitations, can be found in the huge painting of the *Last Judgment*, which was almost certainly only planned and outlined by Giotto himself and left to his assistants to paint. But even the plan, with

the serried ranks of angels singing like the final chorus of an opera, does not reach Giotto's usual standard; the Apostles in the middle, curving from either side of the figure of Christ like characters in a painting by Cavallini, show that Giotto felt far less at ease when dealing with vast, monumental subjects in which the iconography was already long since established, and in which the human element foundered under sheer weight of numbers. The most interesting feature of the *Last Judgment*, besides the experiments with perspective and distance used on the ascending angels, is the figure of Christ itself, serene and powerful as in the *Noli me tangere*. The figure of Enrico Scrovegni offering his chapel to the Virgin Mary is noteworthy; it is certainly a portrait painted from life and is generally considered to have been painted by Giotto himself, not by his assistants.

In the paintings dating from the end of Giotto's stay in Padua a Gothic fluidity of line and less constrained use of materials becomes noticeable; in the final scenes of the cycle including the *Last Judgment*, and in particular the *Vices and the Virtues*, new experiments in realism can be found everywhere. The softening of light values has the effect of making the firm outlines of shapes (always darkly coloured to give depth and relief) more elegant and gentle. These stylistic developments bring us forward to paintings which are generally attributed to the years immediately following the Arena frescoes, that is to say the *Crucifix* in the Tempio Malatestiano in Rimini (*pl. 56*) and the *Crucifix*, completed some years later, in the Arena Chapel (*pl. 57*). In these Giotto demonstrates the mature use of elements which he was beginning to develop in the Arena frescoes. In Rimini Giotto was working in San Francesco (Riccobaldo Ferrarese made a note of this in his *Chronicle* for 1312), but these paintings were destroyed when the church was demolished to make way for the erection of the Tempio Malatestiano, designed by Leon Battista Alberti; only the *Crucifix* remains, without the two paintings which were at either end of the horizontal arms of the cross. Recently the marvellous finial painting has been discovered in London and authenticated by Zeri. This is the

Crucifix that Longhi calls ' Giotto's masterpiece of the years around 1310 ', and which reveals, when compared with the youthful *Crucifix* in Santa Maria Novella (*pls 5-7*), just how much ground Giotto had covered during those twenty years of striving to express humanity in visual terms. His development can be appreciated especially if the two figures of Christ are compared, the later showing, to quote Zeri, ' the uninterrupted modulation of plastic values; the chiaroscuro, whose subtlety and violence rivals that of Masaccio, throws the dying figure into the strongest relief; the rigidity of death has almost gripped the body, the clenched fists being the only remaining sign of life... ' The *Crucifix* in Padua is based on the Rimini *Crucifix*. It certainly came from the workshop of Giotto at the same period, and may even be by Giotto himself, but it is not such a remarkable piece of work; it is a smaller version, and although beautiful, it is not so emotionally charged (perhaps this is due to the less refined medium in which it is painted). In the supreme masterpiece at Rimini the artist recedes into the background behind the marvellous figure of Christ, who is like a Grecian statue of the golden age.

After this period Giotto probably went to Rome (between about 1310 and 1312) to do the huge mosaic of the Navicella which filled one side of the porch in the Old St Peter's; we can imagine the illusion of great space he must have created here, with the sea leading the eye back to the line of the horizon – he repeated that same line in the *St John* in the Peruzzi Chapel (though it is virtually impossible to discern here what is by Giotto and what by his later copiers).

In about 1320, or at any rate at about the time Giotto was working in Florence, and certainly after the mosaic of the Navicella, the Lower Church at Assisi was decorated with frescoes showing the life of St Mary Magdalene, commissioned by the bishop Teobaldo Pontano. They were probably largely painted by Giotto's best pupils (certain figures in the lunettes in the ceiling can be attributed to Giotto himself), but nevertheless the composition and manipulation of light are so much Giotto's own that this series must be regarded as one stage in his development and an

indispensable preparation for the frescoes in Santa Croce.

The years which preceded the two great achievements of Giotto's maturity, the frescoes in the Peruzzi and Bardi chapels in Santa Croce in Florence, saw the production of a great many panel paintings; Giotto was obviously much in demand for this work. For anyone who has seen only Giotto's frescoes, with their bland technique and the black rim outlining each figure like the lead in a stained glass window, these paintings show a new aspect of Giotto's personality. Ghiberti recorded that the *Dormition of the Virgin* (*pls 54-5*), now in Berlin, used to hang beside the *Ognissanti Madonna* in the church of Ognissanti; it was painted at what is often considered to be the highest moment in Giotto's art. The crowd of Apostles and angels appears to fit with some difficulty on to the low, pointed panel, shaped like the tympanum of a Greek temple; the repeated vertical figures contrast dramatically with the absolutely horizontal line of the Virgin Mary and her sepulchre. Above the recumbent figure the serene presence of Christ divides the sea of haloed heads and, like the Apollo of Olympia, appears to be calming the confusion that is about to break out with a single gesture of his arm and the steadfast stillness of his face. I think that Giotto can justifiably be said to have rediscovered classical rhythms; his figures and their heavy formal robes, though set in the Gothic mode, bring back the memory of certain classical bas-reliefs and sculpture, including the Pheidias works of the Parthenon.

Finally, when Giotto had painted cycles of frescoes up and down Italy and achieved great renown, Florence, his own city, decided to entrust to him the two chapels in Santa Croce, the second greatest Franciscan church after the Basilica in Assisi; this church had recently been built to designs by Arnolfo, under the eye of the architect, and the plaster inside was still damp and new. The men who commissioned the frescoes were the richest bankers in Florence, the most important representatives of the mercantile society of the day. The stories of St John the Baptist and St John the Evangelist on the walls of the Peruzzi chapel were the first to be painted, around 1320. The composition is on a

much larger scale than that of the Paduan scenes, and the plan and architecture more complex. The stories occupy the breadth of the wall of the chapel and thus, by not being split up into so many small scenes, attain great power and solemnity; the feeling of space which presides seems to allow each figure its full value, and the drawing of the characters is less wooden and angular than in the Padua cycle. We discover in the scenes of the *Nativity of John the Baptist* or in the richly hung chamber in the *Dance of Salome*, with the cut out statuettes and festoons against the sky like a frieze in one of the richer villas in Pompeii, a new sense of security, a vision of the sweetness of life, reflected in Giotto's painting. The wealth of the merchants, the financial security of the bankers and the by now relatively stable establishment of the Franciscan order all contributed to a life of wealth and ease which had been successfully built up in Florence over the years. And as with Florence, so with Giotto, who regarded the cycles in Santa Croce as the climax of a lifetime's work, and the final achievement of financial security and fame; now, at the age of fifty, he was in a position to supply the most complete proof of his quality as an artist. Besides a new-found dignity and weight in the Santa Croce frescoes, Giotto also achieved a more refined feeling for colour; none of the crude or metallic tones to be found in the youthful frescoes occur here, and the colours are further softened and brought to life by being permeated by light. As well as these developments an increasing love of detail is discernible, as is a more detached observation of people and places (*pls 58-73*).

The *Resurrection of the harlot* (*pl. 58*) is the fresco in which the 'mature' Giotto can perhaps best be appreciated; the story is told against a stupendous architectural backcloth, with memories of Padua and Rimini in the gateway and the arch on the left, filtered through the painter's imagination. The space between the two groups of figures, which is emphasised by the architecture — St John is holding out his arm towards the miraculously cured woman in a line which follows the line of the wall exactly — recalls the *Renunciation* in the Assisi cycle (*pls 12-14*), and the com-

parison of these two scenes provides an excellent scale for the measurement of the ground covered by Giotto between these two cycles. The Assisi style is touchingly archaic and wooden by comparison with the rich, luxurious Florentine style, with its heavy draperies and carefully differentiated faces; we can feel the presence of the wealthy merchants watching from behind the chapel screen. More than the story of St John, this is the story of them, the merchants, Giotto, Florence and the whole fourteenth century.

The frescoes in the Bardi Chapel, so much more straight-forward in their use of material but mutilated by time, and now at last restored, demonstrate the same spacious-ness and maturity, and in addition Giotto has developed here a strong sense of history. The scenes from the legend of St Francis are limited to those which were important to the Franciscan Order and to the Curia, and there are fewer scenes showing the intimate and poetic moments of St Francis' life than there are in Assisi. The Florentine scenes are set in peaceful, calm scenery which harmonizes with the subject. The *Renunciation* (*pl.60*) takes place in front of a square building, classical in conception but with Gothic details, like an altar of peace breaking through the lunette towards a distant horizon. The miniature Arnolfian-classical setting of the *Sanctioning of the Rule* (*pl. 61*) gives the perfect atmosphere to the scene which, though it lacks the intimacy of its counterpart in Assisi, achieves the feeling of a courtly ritual by the use of perfect symmetry. The *Ordeal by Fire* (*pls 62-3*), with the sultan in the cen-tre and the disorganized crowd in Gothic robes standing on the left, leads into the extraordinary, marvellous painting of the *Chapter at Arles* (*pls 64-7*). The perspective of the little cloister has been perfectly interpreted; the triple depth of the background seems to anticipate some of Donatello's spatial exercises on the font in Siena or the altar in Padua. The ample back views of the friars, seen seated on the long seat in the foreground which divides them from the spectators, are far more expressive than the intent profiles of those friars whose faces we can see – in fact they must be some of the most expressive back views in Western painting. This scene in the monastery has an immediacy

and an intimacy which is lacking in the *Burial of St Francis*
(*pls 68-71*), in which, beside the figures of the mourning
friars bent over to embrace the dead saint or performing
the ritual of burial, Giotto has carefully introduced small
'official' portraits of his patrons taking part in the im-
portant ceremony.

On the altar of the Bardi chapel, according to a theory
propounded by Longhi, there was a great polyptych with
scenes from the life of Christ, many panels of which have
fortunately survived and are dispersed among the museums
of the world. The themes of the Padua cycle recur here,
but are refined by far more sensitive use of colour and
light; certain details of perspective, including a new per-
haps slightly ingenuous technique of painting a small head
against a distant background to give the feeling of depth,
show that Giotto has been pursuing his researches in this
direction. The *Adoration*, the *Presentation* and the won-
derfully perspectived *Last Supper*, with the open gallery to
draw attention to the cubic shape of the chamber, all em-
ploy the innovations of light and colour which are always
present in the late work of Giotto. In the *Crucifixion*, which
precedes the two more complex versions in Berlin and
Strasbourg by a few years, there are two figures at the
foot of the cross which are probably portraits of Giotto's
patrons, members of the Bardi family. It is only in the late
works of Giotto that we find portraits of real people, indi-
viduals singled out from the society in which Giotto lived
and worked; this shows a definite step towards the psycho-
logical order of the Renaissance, away from the Middle
Ages. In the staggering *Berenson Deposition* (*pl. 76*), the
group formed by the fainting Mary and the woman support-
ing her, and the group of apostles weeping over the body
of Christ together form an arch, a lunette, which does not
come to a halt (as does the arch in the Berlin *Dormition*)
in the rigid line of the pointed tympanum; here everything
depends on the gently illuminated hillside behind, where
the three dramatic trees stand as symbols of the three
crosses at the Crucifixion, among the suspended angels.
The only head that wears no halo is placed in the middle,
between the hill and the mourning group of apostles, and

29

demonstrates Giotto's sure grasp of the principles of perspective; this play with perspective occurs in the two last Crucifixions, the *Berlin Crucifixion* and the *Strasbourg Crucifixion*, particularly the latter.

In the *Berlin Crucifixion* the crowd of elongated, Gothic figures at the foot of the cross, standing about at different distances, is a further demonstration of Giotto's continued experimenting with perspective, even within the limits set by the circular gold sky. In the *Strasbourg Crucifixion*, which as Longhi recognized was part of a diptych with the small panel in the Wildenstein collection showing the *Virgin in Majesty with Saints and Virtues*, the crowd of heads is replaced or enriched by the heads of horses and their riders, getting smaller as they get more distant in a careful suggestion of depth. The riders against the gilded background recall the effects used in another remarkable Crucifixion, which is otherwise of a very different nature that which was painted by Masaccio and Masolino a century later on the great wall of San Clemente, and here the sky is a real sky, the landscape recedes into the distance as far as the eye can see. Giotto deserves credit for having provided the first solutions to the problems of space; only after a hundred years of research was the problem completely solved.

The other panel of the diptych, the *Virgin in Majesty*, raises the question, always to be considered in Giotto's later works, of the extent of collaboration by a young generation of painters who were nurtured in a culture and ambience quite different from the ones in which Giotto spent his youth. Their painting expresses a more worldly, elegant way of life, an increasing freedom with drawing and materials, and a progressive understanding of the problems concerned with the representation of space.

The paintings of the final years, the panels painted at the same time as or after the Peruzzi and Bardi chapels, which have just been discussed, the frescoes in Assisi painted in the Lower Church after Giotto had left, or the frescoes in the Podestà chapel in the Bargello in Florence, with scenes from the life of St Mary Magdalene (dating from before 1340) were painted by assistants who included in their num-

bers Stefano (Giotto's nephew), Maso di Banco, Puccio Capanna, Taddeo Gaddi and the unknown Master of the Veils who may (according to documents which have come to light recently) be Puccio Capanna. Some of the elongated figures in the small American Wildenstein *Virgin* suggest that it may be by the Master of the Veils. A triptych in Bologna (*pl. 79*) is signed 'OPUS MAGISTRI IOCTI DE FLORENTIA', and is datable to about 1330; the *Enthroned Virgin* on the central panel is considered to be original and authentic. But if the Child with his outstretched hand (plucking curiously at his mother's wimple) is original, the Madonna's fascinating gaze through her long-lidded eyes, with more than a hint of the courtesan, can only be parallelled in the paintings of Stefano or the later Giottino. We know for certain that the painting of the *Stefaneschi Triptych* for the high altar in Old St Peter's, commissioned by Cardinal Stefaneschi and mentioned in his obituary (1343), quoted by Ghiberti and spoken of with great admiration by Vasari, was contracted out to apprentices. The strong, pure colours and lyricism of certain of its sections bring one back to Sienese painting, and again recall the paintings of the Master of the Veils; as Previtali has pointed out, here we find Capanna's elongated figures, and his characteristic placing of the elements of the painting (*pls 74-5*). The panels which made up a further polyptych, now dispersed, are much more obviously Giottesque than this; they comprise the Washington *Virgin*, the *St Stephen* in the Museo Horne (*pl. 77*) and the *St John the Evangelist* and *St Lawrence* in Châalis (*pl. 78*). The solemn Virgin is definitely by Giotto, and so is the beautifully preserved *St Stephen*. The drawing of St Stephen is exceptionally firm and confident; the bluish white robe and the gilded decorations worn over it are more ornate than anything to be found in the earlier paintings, but in the folds of the loose sleeve we find the broad brushstrokes which are the hallmark of the fresco painter. Another sublime painting of Giotto's maturity is the signed *Coronation of the Virgin* in the Baroncelli Chapel in Santa Croce (*pl. 80*); Zeri rediscovered the missing cusp of this, an *Eternal Father*, and called it 'the last testament of the father of Italian painting'; Giotto is 'grave and solemn, and even

though he draws more freely on Gothic ornament and Gothic rhythms, these are tempered by a classical decorum'. The hand of the most ardent admirer and interpreter of Giotto's conquests of perspective, Taddeo Gaddi, can be detected in the execution of some sections.

It was quite to be expected that the work which took up most of Giotto's time during the last years of his life was a building; he had always aspired to being an architect, and the details in his paintings show tremendous grasp of the subject. Solid, clean lines distinguish the bell tower that bears his name, which stands beside the cathedral of Santa Maria del Fiore in Florence, designed by his influential forerunner Arnolfo di Cambio. The contours of the tower are outlined by angular pilasters, built in clumps like stems of bamboo or some other plant. The construction of the tower was largely according to Giotto's designs, though some of the detail may have been made to conform to a more Gothic vision, with elongated, refined shapes as in the Stefaneschi polyptych or the Baroncelli *Coronation of the Virgin*. There could, however, be nothing more Giottesque than the motifs, with their echoes of Cosma and Arnolfo, which decorate the first two bands from ground level, built during Giotto's lifetime. Some of the other panels as well reflect his ideas and designs and were clearly planned under his close direction.

Giotto and the Critics

An account of Giotto's fate at the hands of critics and historians would be too long and complex to be more than hinted at in a study of this brevity. From Cennino Cennini's judgment in the *Book of the Arts* (1390), where the most famous definition is to be found: 'Giotto translated the art of painting from Greek into Latin', to the words of Ghiberti (1450): 'Giotto achieved a level of genius which others are only now striving to reach'; from the admiration of Vasari, who in general despised Gothic art, but made an honourable exception of Giotto, until we come to Longhi, who wrote that Giotto had 'discovered in painting the

glory of our language ', there have been countless studies of Giotto. His genius has overcome all prejudice and convention: throughout the fourteenth century he continued to be extravagantly praised; the fifteenth century continued to value his work, and even the sixteenth century, so far removed from his outlook, could not resist his appeal. The same is true of the seventeenth century, which from the visual point of view was the very opposite of Giotto's epoch. It was only the eighteenth century, apparently frivolous but in fact deeply destructive and iconoclastic, which, with the remarkable exception of the admirable Patch, an Englishman, covered up and destroyed many of the works of Giotto. It was Patch, an art lover, who tried to save the frescoes being destroyed in the church of the Carmine in Florence, believed to be by Giotto (in fact they were by Spinello Aretino). Patch went so far as to copy the frescoes before their destruction. Finally, in the nineteenth century the excessive and absurdly romantic appreciation of Giotto multiplied the pictures attributed to the painter beyond all proportion. It was in fact the period when the term Giottesque was used loosely and inappropriately, becoming a virtually indispensable adjective for practically every production of the thirteenth century.

Cited below (from an immense literature) are the principal stages in the complex process of reassessment: Cavalcaselle's History (1885) and the works of Thode (1904); Rintelen's monographs (1912 and 1923); Toesca's entry in *Florentine Painting of the fourteenth century* (1929); articles by Brandi (1938-9); Offner's essay (1939); Toesca's monograph (1941); notes by Longhi in *Giudizio sul Duecento* (1948) and his *Giotto spazioso* (1952); Toesca's work on the *Fourteenth century* (1951); Gnudi's long monograph (1959), which includes an exhaustive bibliography; Battisti's profile (1960); the recent essay by Meiss (1960); Salvini's monograph (1962); Gioseffi's *Giotto the architect* (1963); articles in *Paragone* by Volpe and Zeri; studies of the Peruzzi frescoes by Borsook and Tintori (1965), and recent writings by Previtali (1963 and 1965).

Notes on the Plates

1 Isaac drives out Esau. Fresco. Assisi, San Francesco. Detail. With the fresco showing Isaac blessing Jacob, one of the first three histories painted by Giotto in Assisi, c. 1290.

2 Lamentation. Fresco. Assisi, San Francesco. Detail. Giotto's biblical paintings have been the subject of considerable debate among the critics, both with regard to the chronology of the pictures and Giotto's part in their execution; both problems are strictly relevant to his early life. The historian Riccobaldo Ferrarese records that Giotto was active in the church in Assisi in 1312. The opinion put forward by Thode in 1885 that the *Story of Isaac* and some other stories of Joseph and of Christ were Giotto's work was taken up by Toesca and in recent years has been accepted by the majority of modern critics (Berenson, Cecchi, Longhi, Gnudi, Salvini, Meiss, Previtali). Coletti attributes the *Story of Isaac* to a hypothetical and unknown Master of the Isaac cycle; this was in fact a view generally accepted until a few years ago. Salmi considers the *Resurrection* and the *Lamentation* to be the work of Giotto, but will not admit the Isaac series; Bauch firmly attributes this series to Giotto but rejects the attribution of the stories of Christ and Joseph. Brandi on the other hand admits nothing before the Story of St Francis. The vault of the first arch painted with the *Doctors of the Church* (at the same time as the inner vaulting) has been the object of discussion since it was the Decretals of Boniface VIII in 1294 which instituted the state of Doctor of the Church, and it is thus that a date has been put forward which has moved many of the critics to alter the date of the beginning of the frescoes and the presence of Giotto in Assisi. This problem is simplified if we remember that the cultus of the Doctors of the Church existed before 1294.

3 Joseph sold into slavery (Joseph in the well). Fresco. Assisi, San Francesco. Detail.

4 Madonna and Child. Panel, 180×90 cm. Florence, San Giorgio alla Costa. Mentioned by Ghiberti; attributed, by Offner, to the Master of St Cecilia (1927), and this was confirmed by Toesca (Offner now attributes it to the Master of the Crucifix in Santa Maria Novella). The attribution to Giotto, proposed by Oertel (1937) was admitted by Longhi (1959), Salvini (1952), Bauch (1953), Gnudi (1948) and Battisti (1960). Longhi regards it as a very early work, Gnudi dates about 1296, Offner about 1301-03 and Salvini to the Padua and the *Ognissanti Madonna* period.

5 Crucifix. Panel, 578×406 cm. Florence, Santa Maria Novella. Detail. Mentioned by Ghiberti as being by Giotto. Ricuccio del

fù Puccio del Mugnaio stated in his will in 1312 that an oil lamp should be kept burning perpetually in front of this painting. At the Giotto exhibition in 1937 most critics were agreed on its description as an early work of Giotto (Coletti, Salmi, Oertel, Toesca, Longhi). Perkins and Offner on the other hand do not attribute it to Giotto; in 1956 Offner assigned it, with the *Madonna* of San Giorgio alla Costa, to a 'Master of the Crucifix in Santa Maria Novella'. Brandi attributes the figure of Christ to Giotto (*c.* 1300) but the mourners to the collaborators of the *Lamentation*.

6 Crucifix. Panel. Florence, Santa Maria Novella. Detail.

7 Crucifix. Panel. Florence, Santa Maria Novella. Detail.

8-9 St Francis giving his mantle to a poor knight. Fresco, 270×230 cm. (as the others of this cycle, pls *10-32*). Assisi, San Francesco. Giotto was summoned to paint this cycle by Fra' Giovanni di Muro, general of the Franciscan Order from 1296 to 1305. The cycle is named as Giotto's work by Vasari (1568) and, before that, by Ghiberti (c. 1450), who said of these paintings that Giotto 'is painting most of the lower part of the church of the Order of Friars Minor in Assisi'. Some critics have refuted this: White in 1821, Rumohr in 1827, Rintelen in 1912 and recently Offner (1939 and 1956) and Meiss (1960), drawing attention to the difference between these paintings and the Padua frescoes. All other critics agree on the attribution to Giotto (with the help of collaborators) even though they disagree over dates. Most of them agree also that the first painting and the last nine of the cycle are based on Giotto's ideas but painted by someone whose identity is unknown. The episodes follow St Bonaventure's *Legenda maior*, written between 1260 and 1263 and based on oral tradition and the earliest biographies of St Francis.

10 Dream of the palace and arms. Assisi, S. Francesco.

11 The Crucifix of St Damian speaks to St Francis. Assisi, San Francesco.

12-14 St Francis renouncing the world. Assisi, San Francesco.

15 Dream of Pope Innocent III. Assisi, San Francesco.

16 Sanctioning of the rule. Assisi, San Francesco.

17 Vision of the fiery chariot. Assisi, San Francesco. Detail.

18-19 Vision of the fiery chariot and Vision of the thrones. Assisi, San Francesco.

20-1 Expulsion of the demons from Arezzo. Assisi, San Francesco.

22-3 Miracle at Greccio. Assisi, San Francesco.

24-5 Miracle of the spring. Assisi, San Francesco.

26 St Francis preaching to the birds. Assisi, San Francesco. Detail.

27-8 Death of the Knight of Celano. Assisi, San Francesco.

29 St Francis preaching before Honorius III. Assisi, San Francesco.

30 Lament of the Poor Clares. Assisi, San Francesco. This and the two preceding scenes (the *Ascension of St Francis* and the *Testing of Stigmata*) and the six following scenes were probably planned and outlined by Giotto, but only small portions were painted by him. In the work of his assistants one painter's hand is very distinct, and this has been thought to be the hand of the Master of the St Cecilia.

31 Apparition to Gregory IX. Assisi, San Francesco. Detail.

32 St John the Evangelist. Panel, 91×60 cm. Florence, Museo dell'Opera di Santa Croce. This panel was part of the *Badia Polyptych*, one of five panels which showed *St Nicholas, St John*, the *Virgin and Child, St Peter* and *St Benedict*. Although Ghiberti and other early writers named this as a polyptych by Giotto, all trace was lost of it later. Its rediscovery and attribution were due to Thode (1885) and were admitted by Suida, Fabriczy and Beenken. Oertel and Salmi regarded it as a work by Giotto's studio; Sirèn, Volback, Rintelen, Van Marle, Berenson, Offner, Brandi and Toesca as the work of a disciple. Procacci has produced documentary proof that this was the *Badia Polyptych*. Recent critics are agreed on this point (Longhi, Gnudi, Salvini).

33 St Benedict. Part of a polyptych. Panel, 91×60 cm. Florence, Museo dell'Opera di Santa Croce. See note to *pl. 32*, above.

34-5 Virgin in majesty. Panel, 325×204 cm. Florence, Uffizi. This has been attributed to Giotto from the beginning (Ghiberti), and was entirely painted by his hand. Painted according to critics shortly before the Padua frescoes (Thode, Toesca, Coletti), or immediately after (A. Venturi, Rintelen, Weighelt, Volbach, Kauffmann, Offner, Brandi, Gnudi, Battisti, Salvini). It may be considered to be contemporary with the Padua frescoes, that is between 1303 and 1308.

36 Joachim retires to the sheepfold. Fresco, 200×185 cm. (as the others in the cycle, *pls 37-53*). Padua, Arena Chapel. This cycle, which covers the walls of the Arena Chapel, illustrates stories of Joachim, St Anne and the Virgin. It was attributed to Giotto by Riccobaldo Ferrarese (1312) and by Francesco da Barberino. The

chapel was consecrated in 1303. The dating of this cycle (the attribution of which has never really been disputed) varies between 1303 and 1312, but it is probably between 1304 and 1308. The last painting of the series was thought to be the *Last Judgment*, painted on the wall of the façade, with the help of many assistants; collaboration in the other stories is less noticeable, probably because the assistants chosen were of high quality and were under close supervision.

37 The Annunciation to St Anne. Padua, Arena Chapel.

38 The Sacrifice of Joachim. Padua, Arena Chapel.

39 Joachim's dream. Padua, Arena Chapel.

40-1 The Meeting at the Golden Gate. Padua, Arena Chapel.

42 Birth of Mary. Padua, Arena Chapel. Detail.

43 Marriage of the Virgin. Padua, Arena Chapel.

44 Annunciation. Padua, Arena Chapel. Detail.

45 Nativity. Padua, Arena Chapel. Detail.

46 Presentation at the temple. Padua, Arena Chapel.

47 Flight into Egypt. Padua, Arena Chapel.

48 Scourge of the Innocents. Padua, Arena Chapel.

49 Baptism of Christ. Padua, Arena Chapel. Detail.

50 Arrest of Jesus. Padua, Arena Chapel.

51 Flagellation. Padua, Arena Chapel.

52 Jesus before Caiaphas. Padua, Arena Chapel.

53 Crucifixion. Padua, Arena Chapel.

54-5 Dormition of the Virgin. Panel, 75×178 cm. Staatliche Museen, Berlin. Mentioned by Ghiberti, it used to hang in the church of Ognissanti beside the *Madonna in Majesty*, now in the Uffizi. Removed from the church in about 1550-1568, it passed through a variety of collections, and finally, in 1913, came into the Kaiser Friedrich Museum. Some critics have attributed it to the studio or the style of Giotto (Brandi, 1939), but most now agree that it is by Giotto (Longhi, 1948; Toesca, 1951; Gnudi, 1959; Slavini, 1962) The date varies between 1315 and 1325.

56 Crucifix. Panel, 430×303 cm. Rimini, Tempio Malatestiano. Detail. Assigned to a follower of Giotto in 1883 by Cavalcaselle and to a local Rimini painter by Bauch, Van Marle, Ricci, Salmi, Brandi, Lavagnino, Oertel, Sinibaldi; Toesca thought its style close to Giotto's own (1929); Berenson and Cecchi attributed it to a Florentine follower of Giotto; Longhi first affirmed that it was by Giotto (1934 and 1948), and was later joined by Coletti, Gamba, Bertini-Colosso, Mariani, Toesca, Zeri (who identified the finial painting of the Redeemer in the Jeckyll collection), Gnudi, Battisti, Salvini and Previtali; Giotto's part in it was thought small by Van Marle (1935), Salmi (1935), Beenken and Suida. It is variously dated immediately before or immediately after the Padua period.

57 Crucifix. Panel, 223×164 cm. Padua, Arena Chapel. Listed by Cavalcaselle in 1864, and assigned to a student or the studio of Giotto by Rintelen, Beenken, Vitzthum, Suida, Weigelt and Brandi; it is attributed to Giotto, with the collaboration of assistants in places, by Valalà, Longhi, Gnudi, Zeri, Salvini.

58 Resurrection of the harlot Fresco. Florence, Santa Croce, Peruzzi Chapel. Detail. The frescoes in these two chapels, listed by Ghiberti with the Giugni and Tosinghi-Spinelli Chapels (now lost) were also mentioned by the Anonimo Gaddiano, by Antonio Billi and by Vasari. Discovered in 1849 (Peruzzi) and 1852 (Bardi), having been plastered over at the beginning of the eighteenth century, they were badly restored and completely repainted. The cleaning and restoration executed in 1958-9 (Bardi) and 1962-3 (Peruzzi) has revealed the original work, with some gaps but basically sound in the Bardi Chapel, without gaps but badly damaged in the Peruzzi Chapel. The date of the frescoes is between 1317, the date of the canonization of St Louis of Toulouse, and 1329, the year of Giotto's departure for Naples.

59 Ascension of St John the Evangelist. Florence, Santa Croce, Peruzzi Chapel.

60 St Francis renouncing the world. Florence, Santa Croce, Bardi Chapel. Detail.

61 Sanctioning of the Rule. Florence, Santa Croce, Bardi Chapel. Detail.

62-3 Ordeal by fire. Florence, Santa Croce, Bardi Chapel.

64-7 Chapter at Arles. Florence, Santa Croce, Bardi Chapel.

68-71 Burial of St Francis. Florence, Santa Croce, Bardi Chapel.

72 Apparitions to the Bishop and to Friar Augustine. Florence, Santa Croce, Bardi Chapel. Detail.

73 St Francis receiving the stigmata. Florence, Santa Croce, Bardi Chapel.

74 St Peter enthroned. Panel. Rome, Pinacoteca Vaticana. Central panel of the *Stefaneschi Triptych*, painted for the high altar of Old St Peter's; mentioned in the obituary of the Cardinal (1347) and by Ghiberti, it is regarded as a studio painting by most art historians (Supino, Munoz, Gamba, A. Venturi, Rintelen, L. Venturi, Mather, Coletti, Toesca, Longhi, Salvini and Previtali; the latter regards it as by the master of the Veils).

75 The Beheading of St Paul. Right-hand panel of the Stefaneschi triptych. Panel. Vatican Gallery, Rome.

76 Deposition. Panel, 44.5 × 43 cm. Berenson Collection, Florence. With seven other paintings (the *Adoration of the Magi* in the Metropolitan Museum, New York; the *Presentation in the temple* in the Gardner Museum, Boston; the *Last Supper, Crucifixion* and *Descent to Limbo* in the Alte Pinakothek, Munich, the *Pentecost* in the National Gallery, London) it was part of an altarpiece which Longhi thinks was painted for Santa Croce, possibly for the Bardi Chapel. Rumohr, Gnudi and Previtali agree with Longhi. Cavalcaselle, Brandi, Toesca, Salmi and Salvini think it was painted in Giotto's studio.

77 St Stephen. Panel of polyptych, 84 × 54 cm. Florence, Museo Horne. Together with the *St John the Evangelist* and the *St Lawrence* in Châalis, and the *Virgin and Child* in the National Gallery of Art in Washington, this formed part of a polyptych reconstructed by critics (Offner, Nather, Longhi) and almost unanimously attributed to Giotto. Those who dissent include Valentiner, Constable, Siren, Supino, Weigelt, Beenken and Brandi.

78 St Lawrence. Panel, 81 × 55 cm. Musée Jacquemart-André, Châalis. Part of a polyptych.

79 Madonna and Child enthroned. Panel, 91 × 340 cm. Pinacoteca, Bologna. Central panel of a triptych, signed ' OPUS MAGISTRI IOCTI DE FLORENTIA ', came from the church of Santa Maria degli Angeli, and is generally considered to have come from Giotto's studio, with a little painting by Giotto himself in the central group.

80 Coronation of the Virgin. Panel, 183 × 323 cm. Santa Croce, Florence. This is the central panel of the *Baroncelli Polyptych*, signed ' OPUS MAGISTRI IOCTI ' and mentioned by Ghiberti, and most historians regard it either as a studio work or the work of Taddeo Gaddi, with detail by Giotto. Longhi (1948) and Zeri (1957) consider it to be the work of Giotto, with assistants, and Zeri (1962) has identified the finial painting of the *Eternal Father* in the Fine Art Gallery in San Diego, Calif.

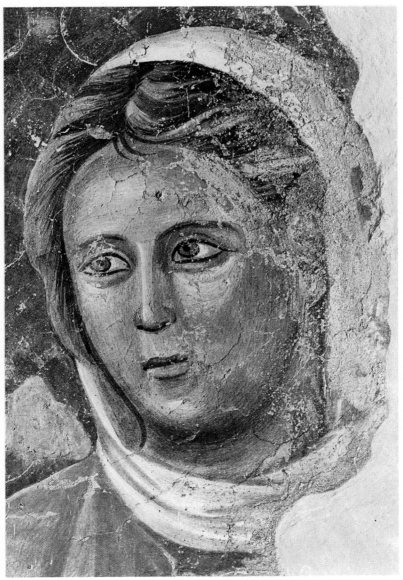

1

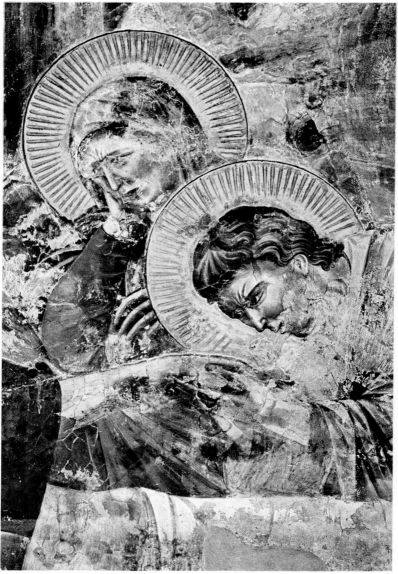

2

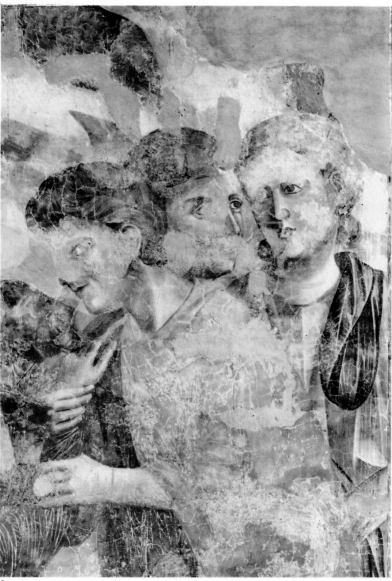

3

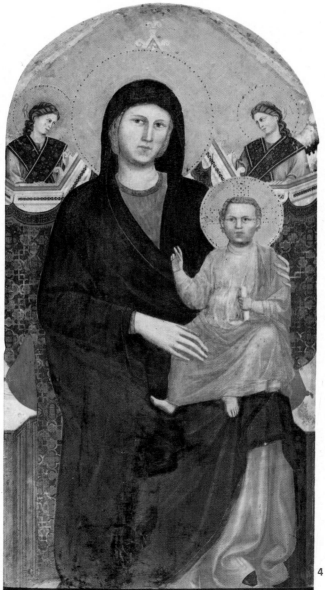

4

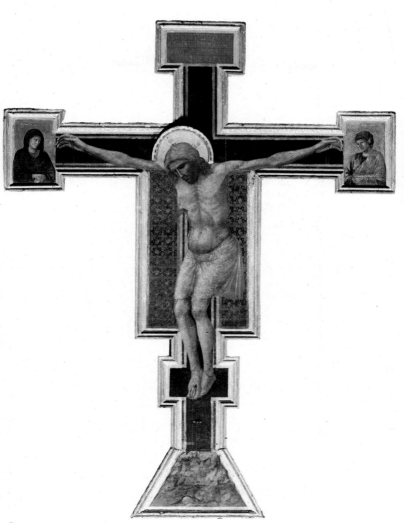

5

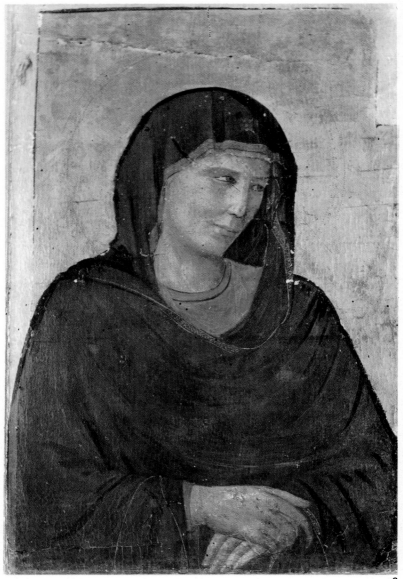

6

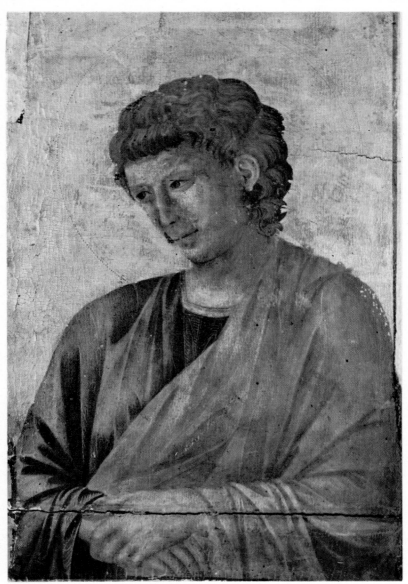

7

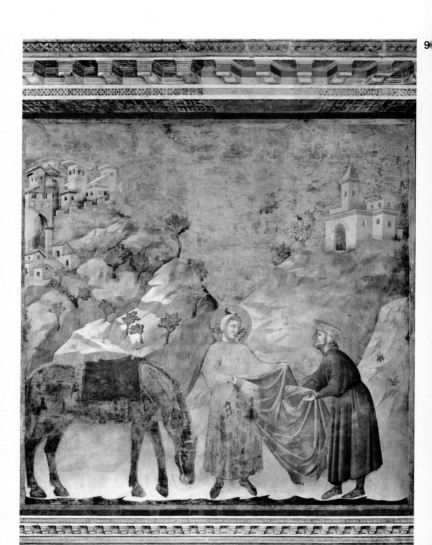

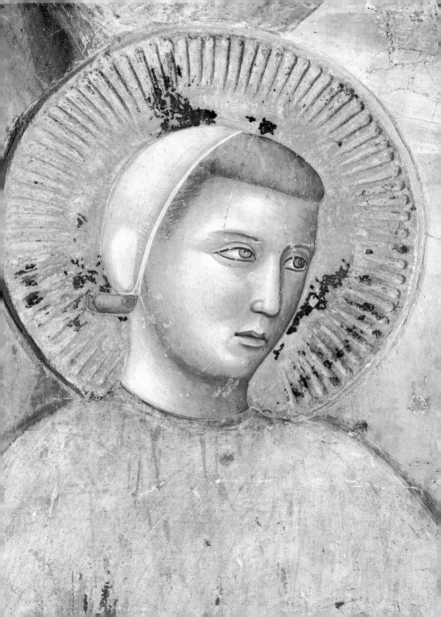

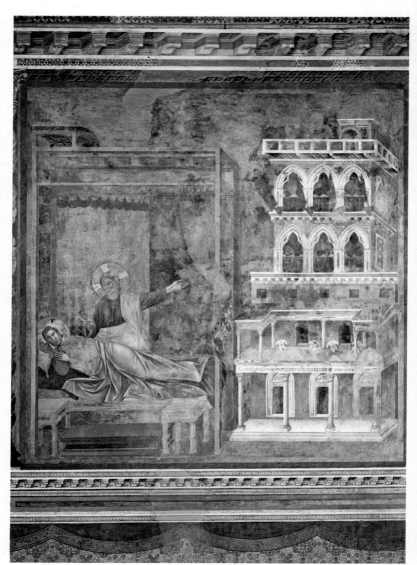

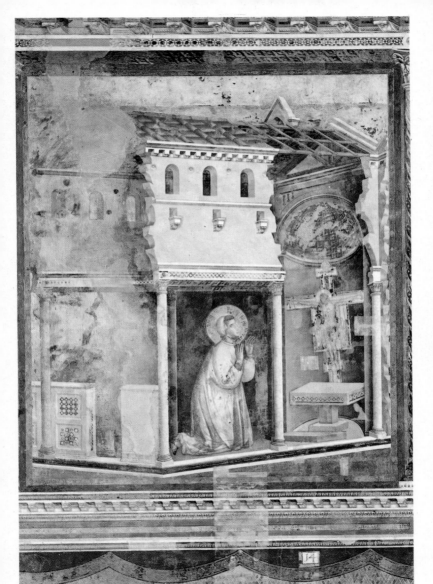

11

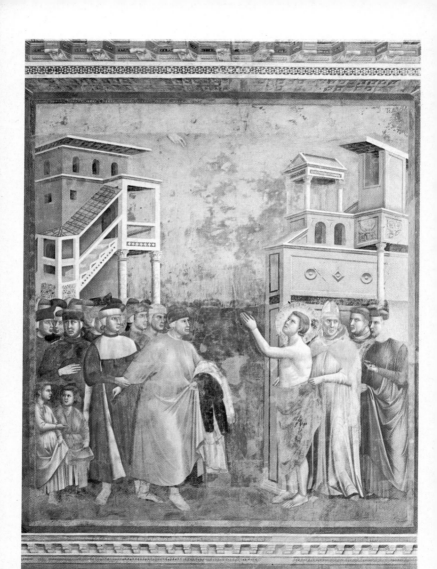

12

14

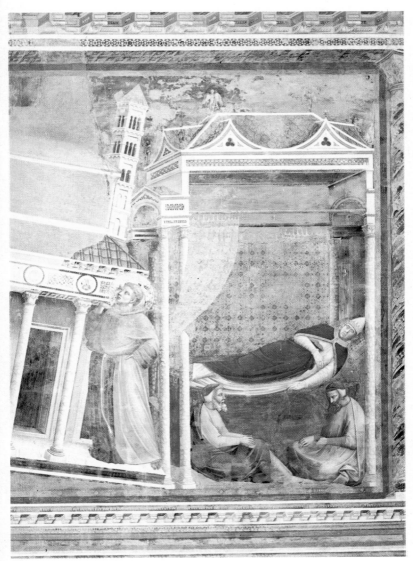

15

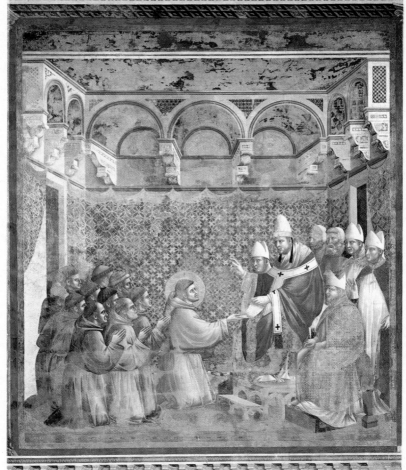

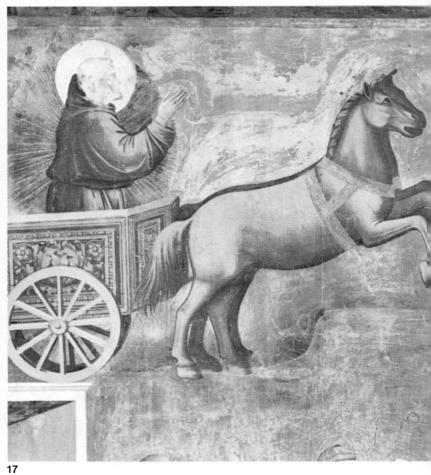

17

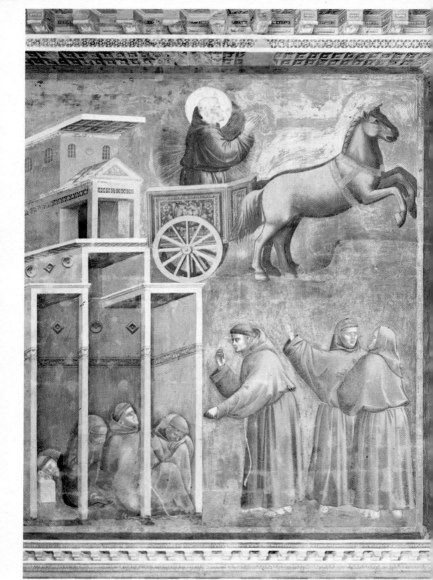

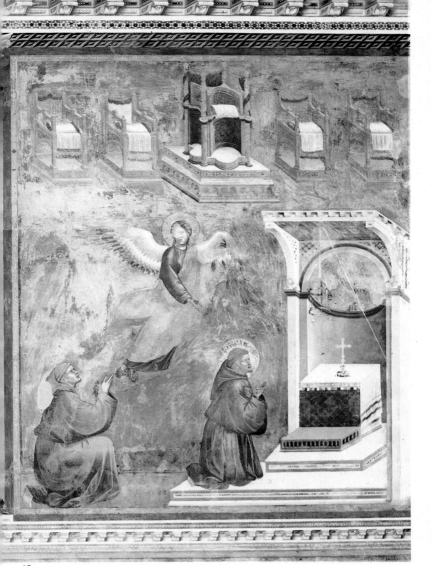

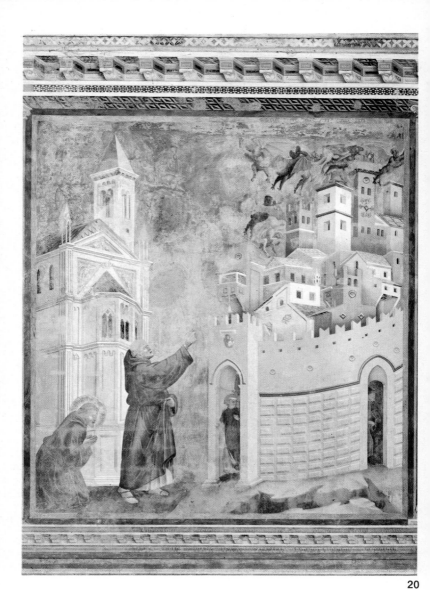

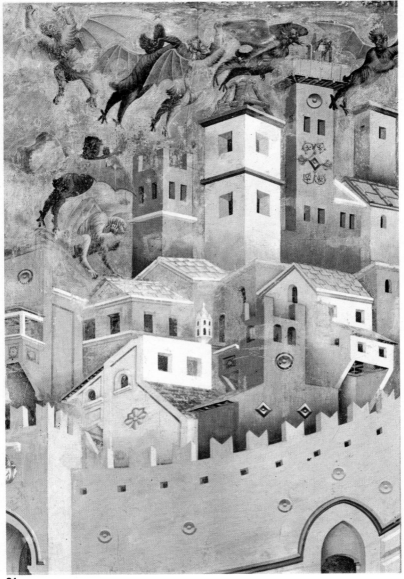

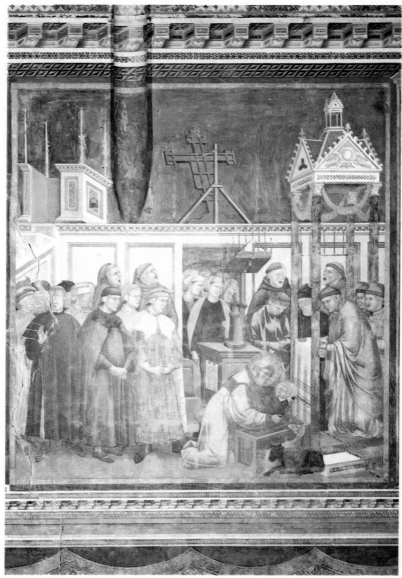

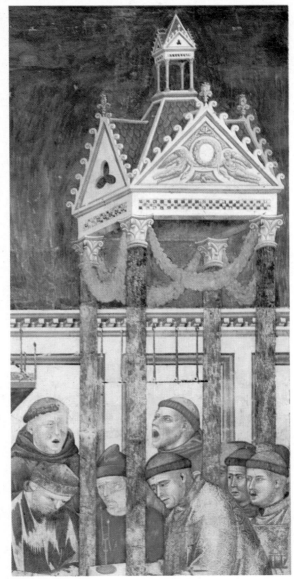

23

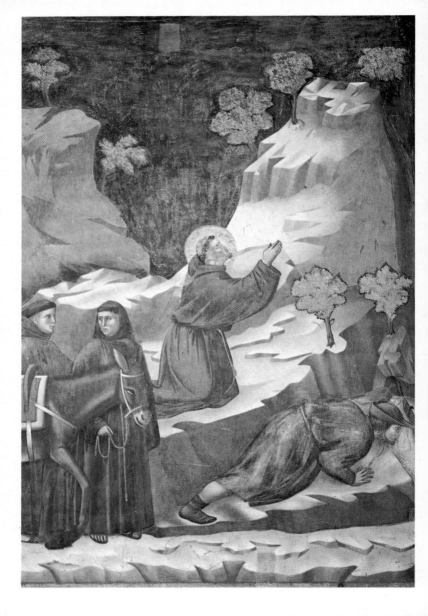

25

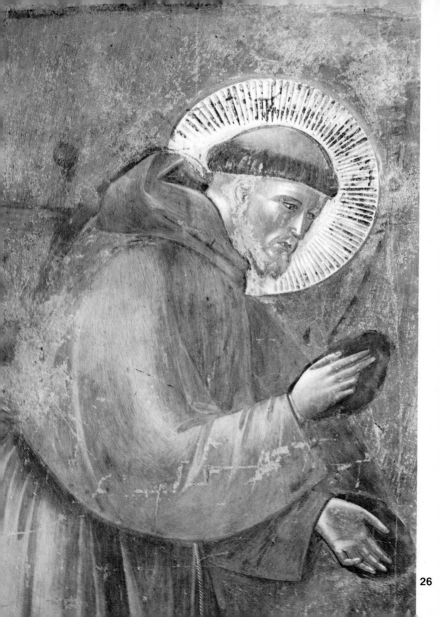

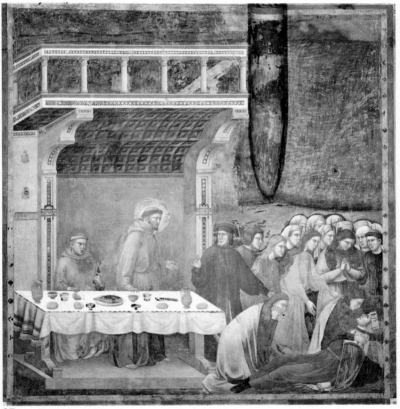

27

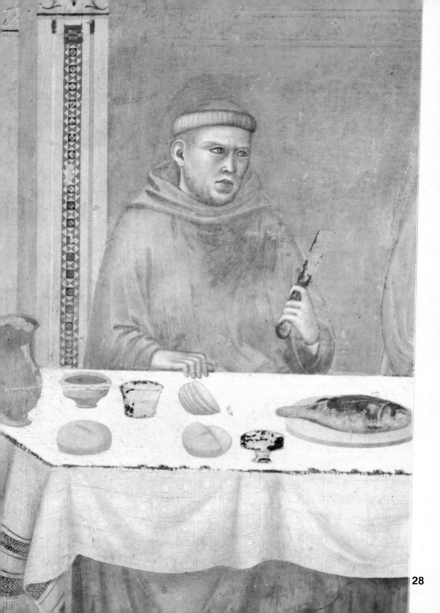

28

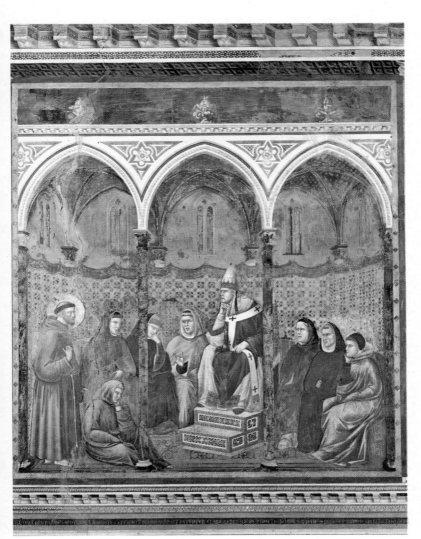

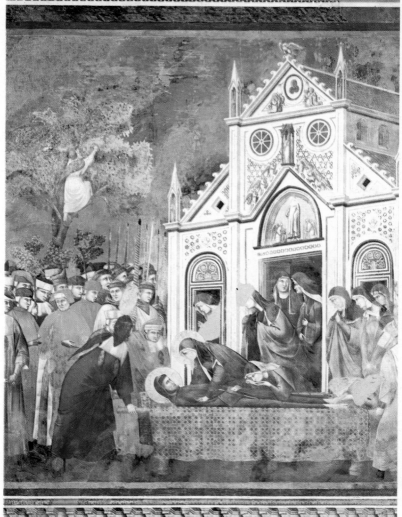

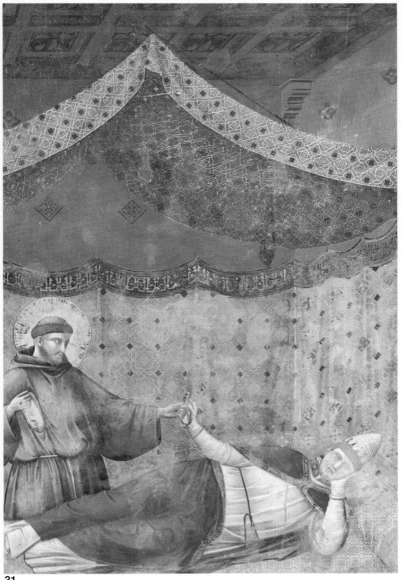

31

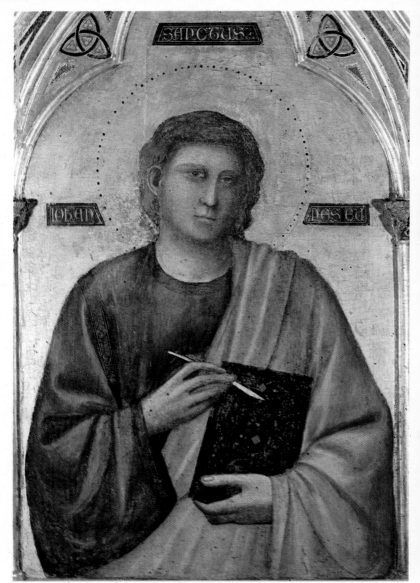

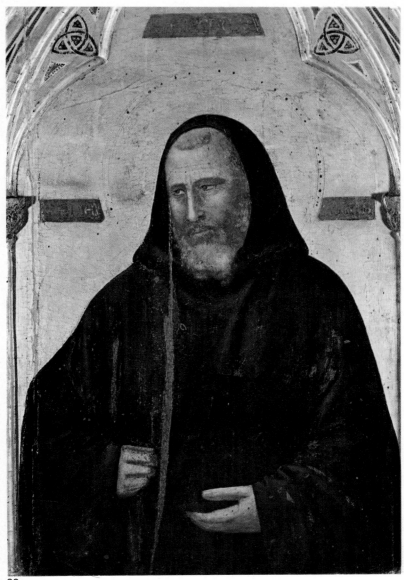

33

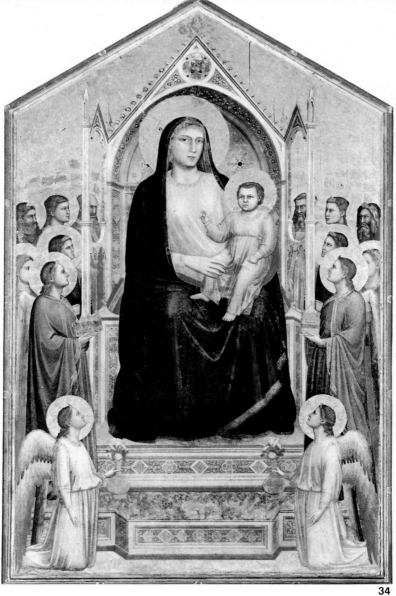

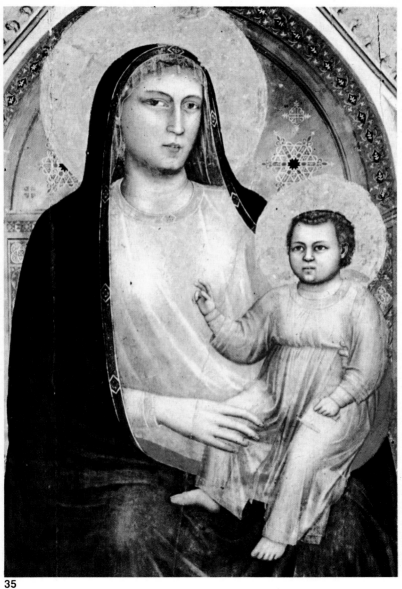

35

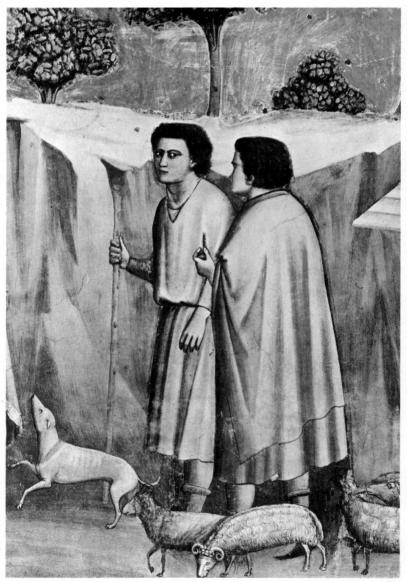

36

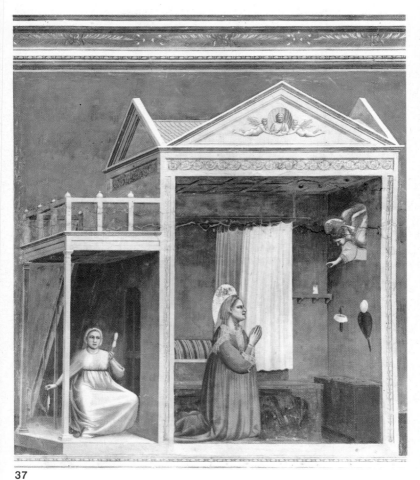

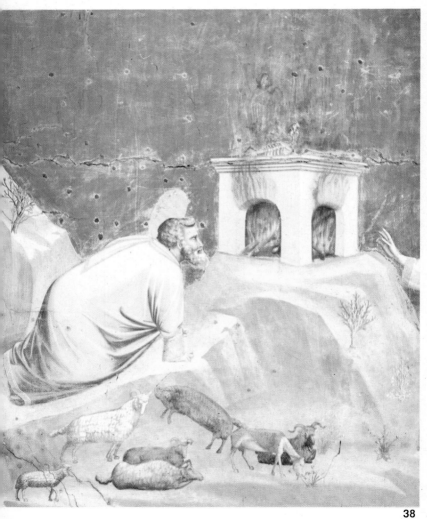

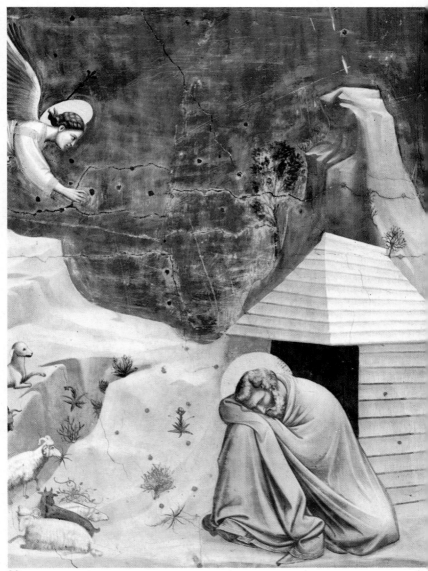

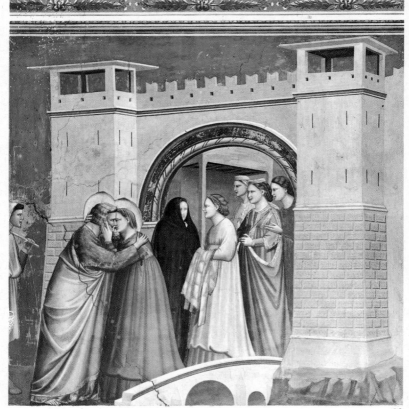

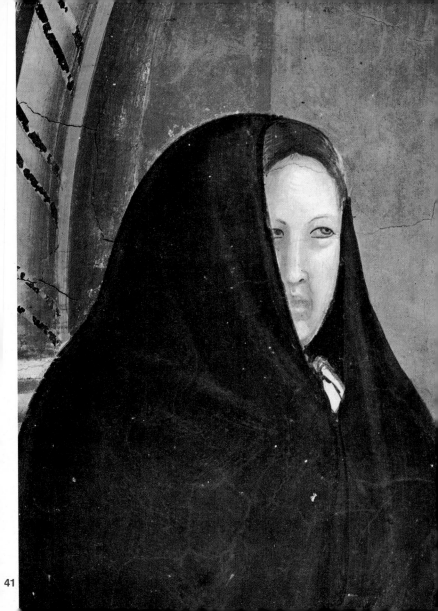

41

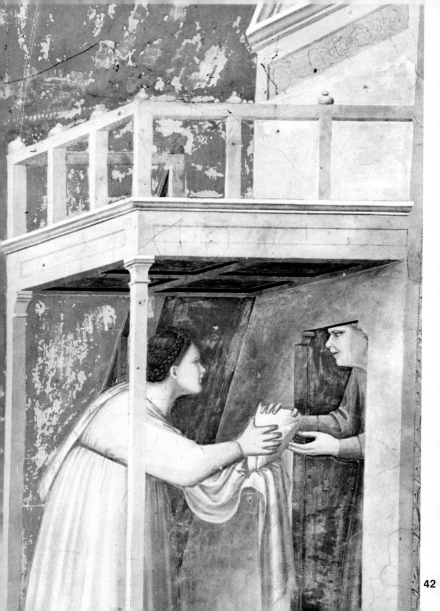

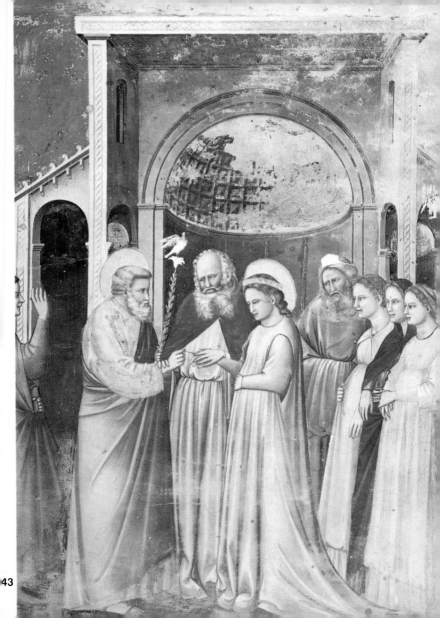

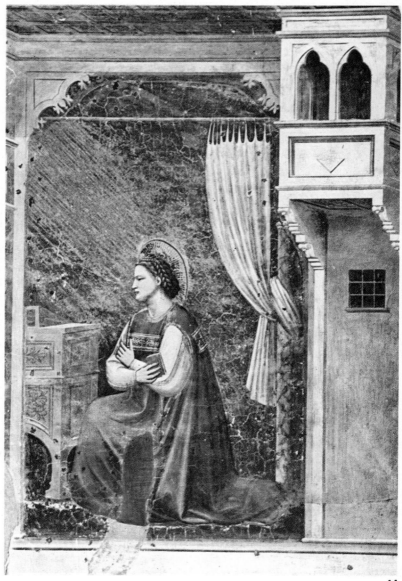

44

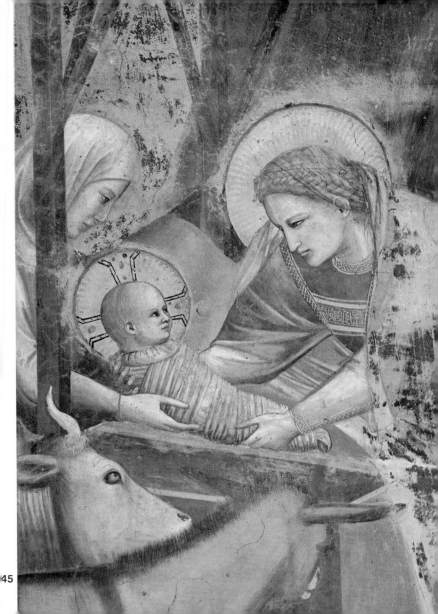

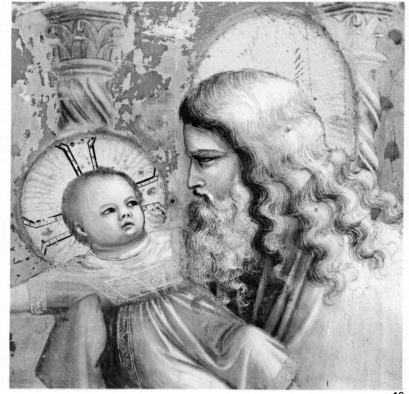

46

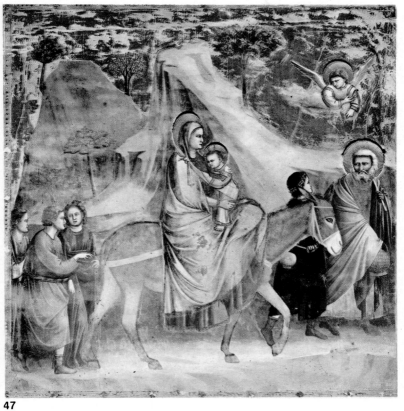

47

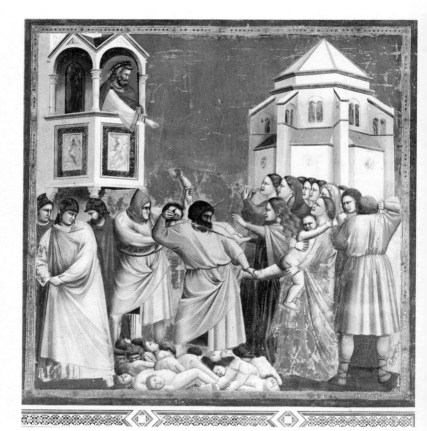

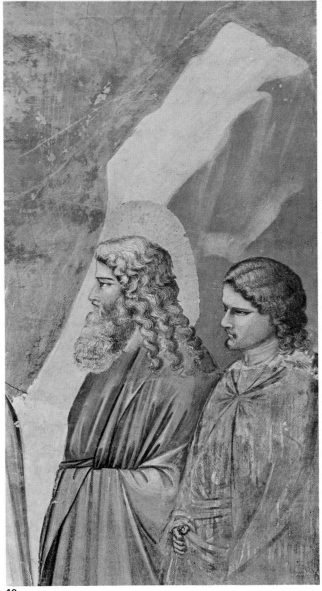

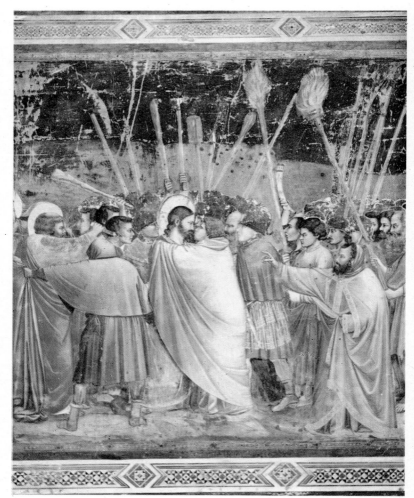

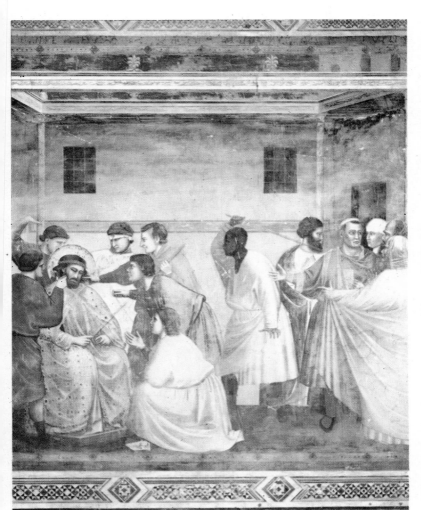

51

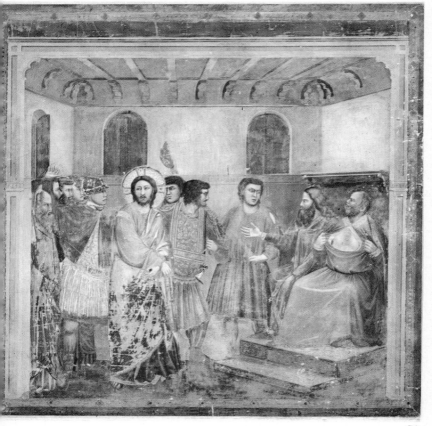

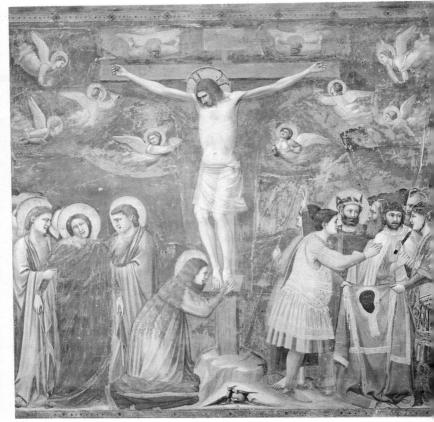

53

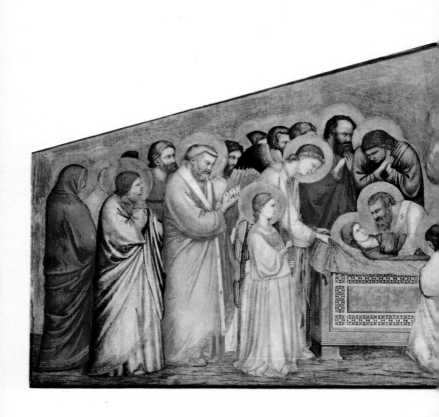

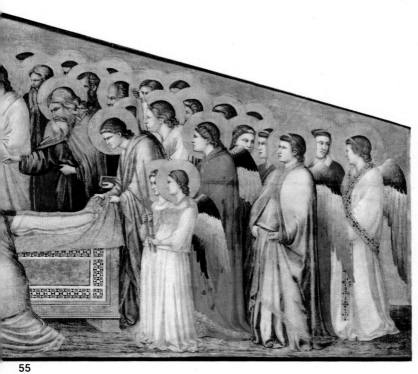

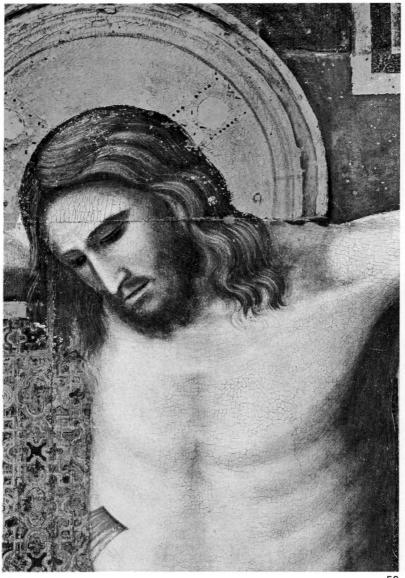

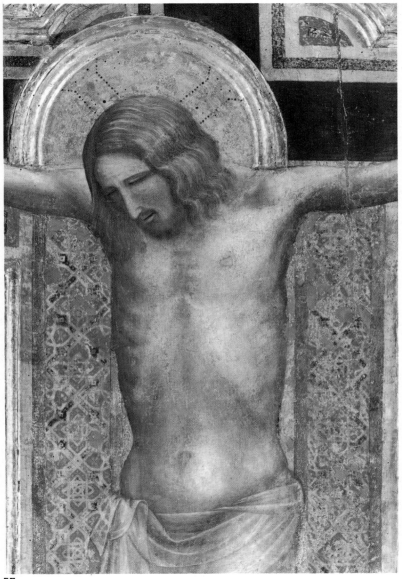

57

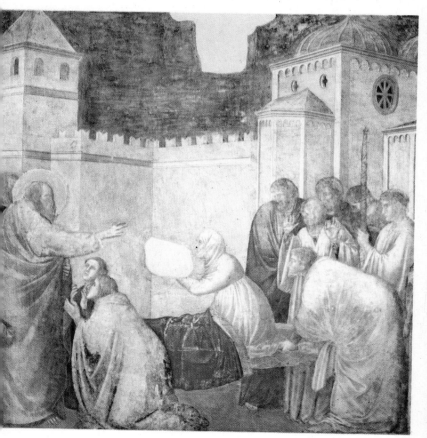

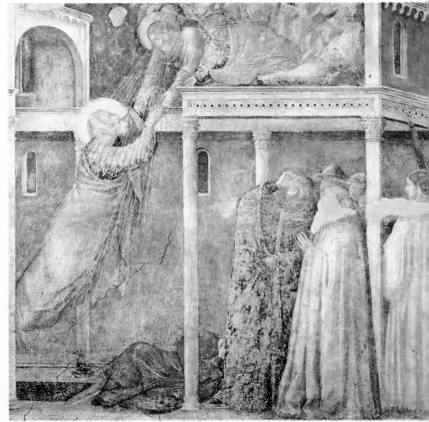

59

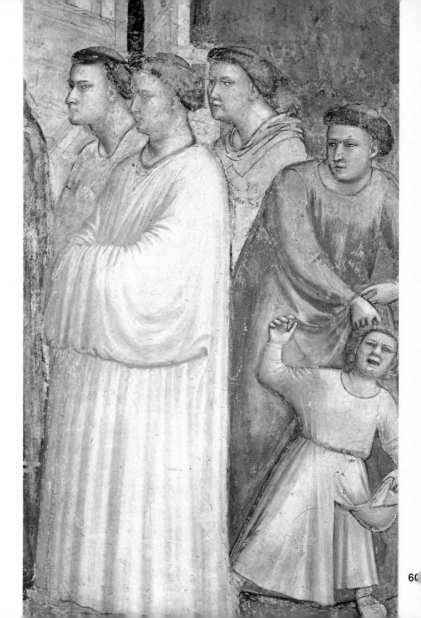

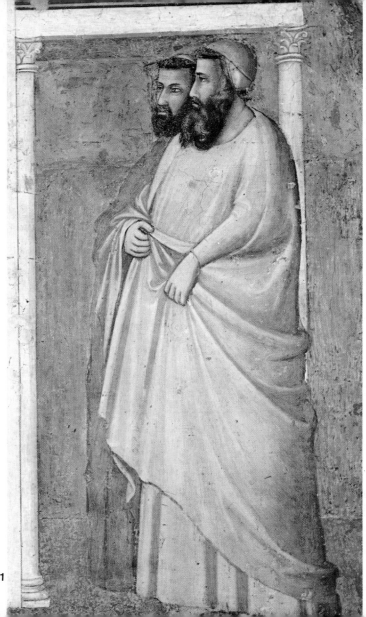

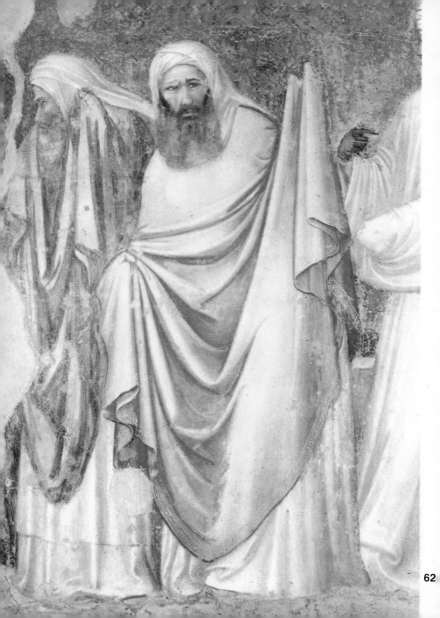

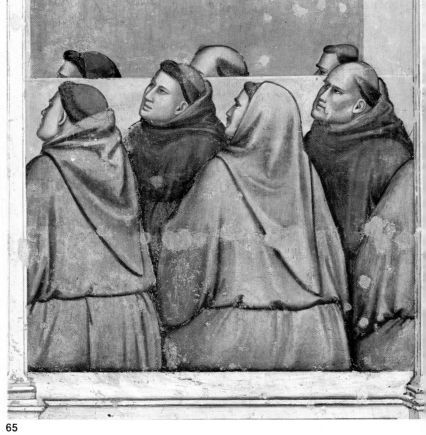

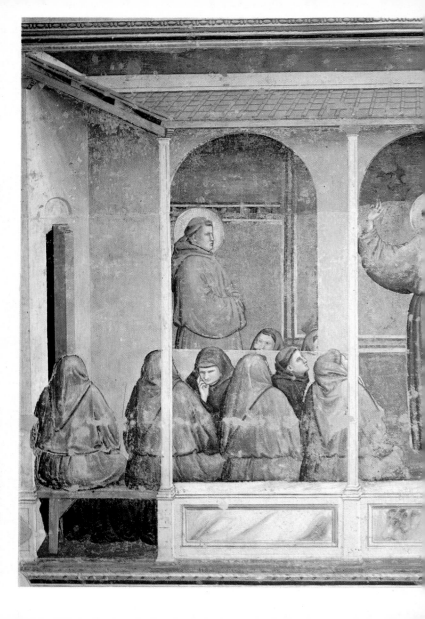

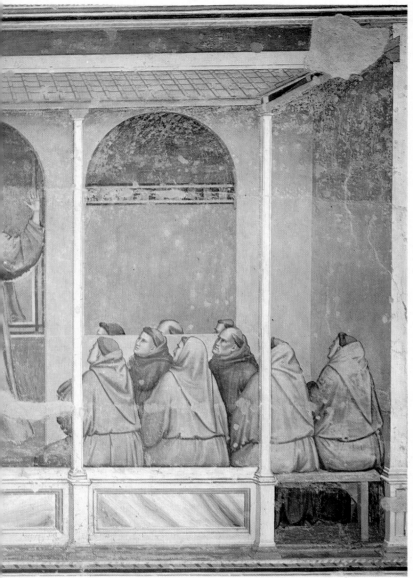

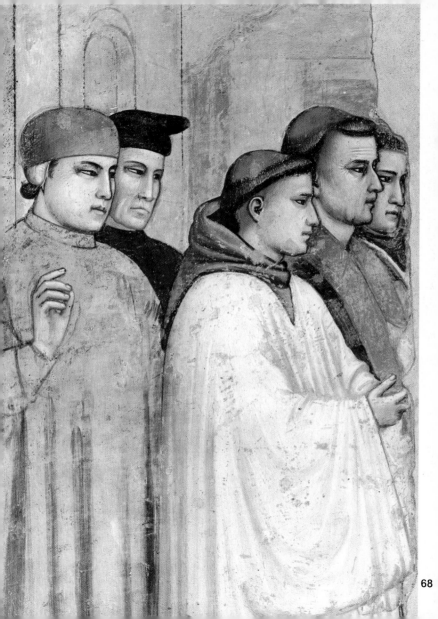

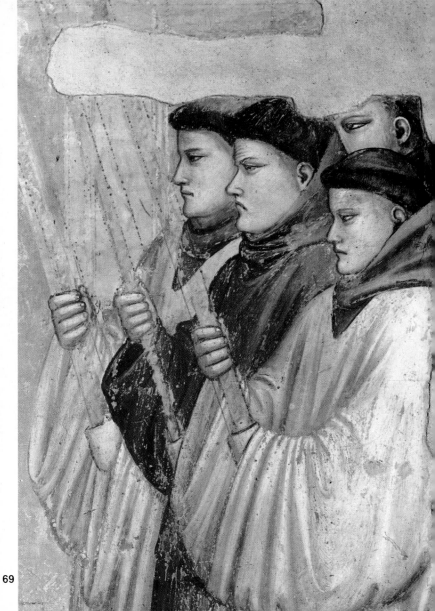

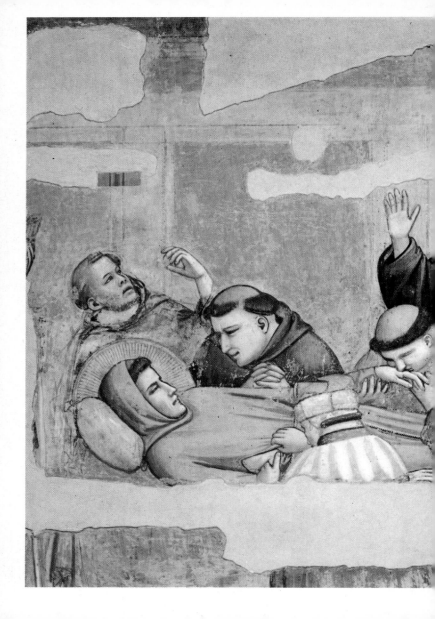

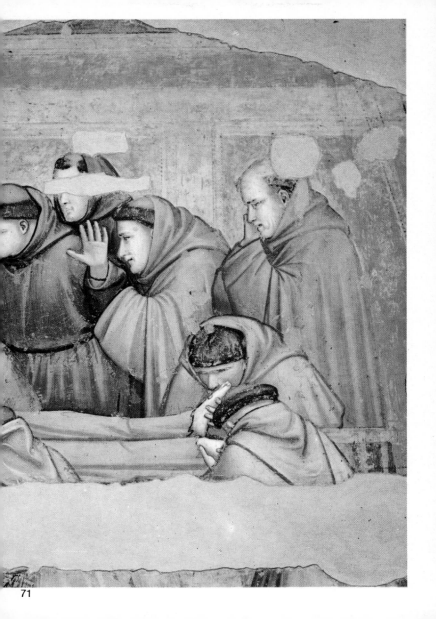

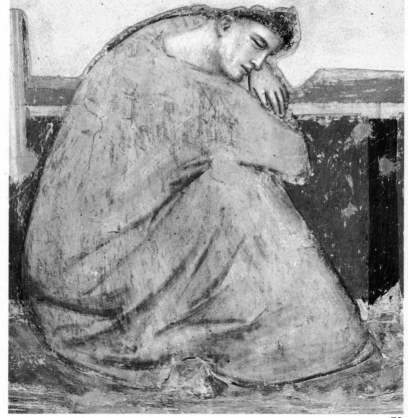

72

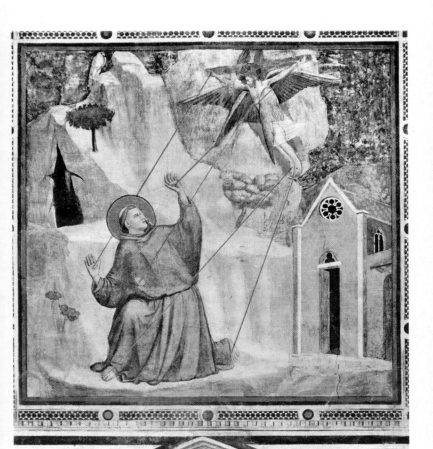

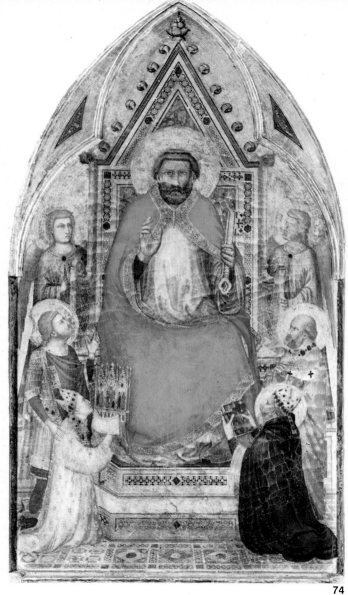

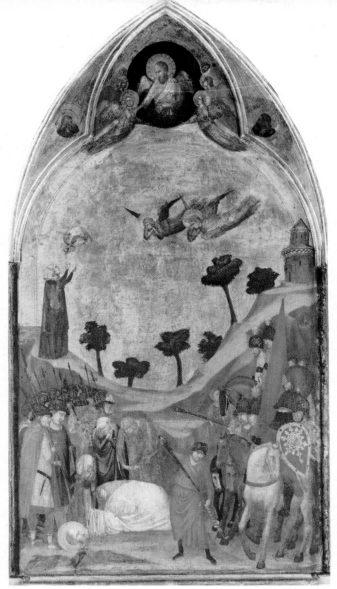

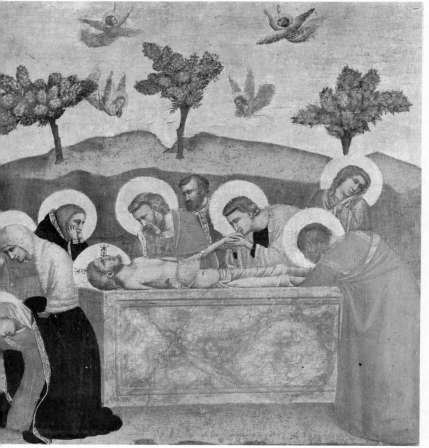

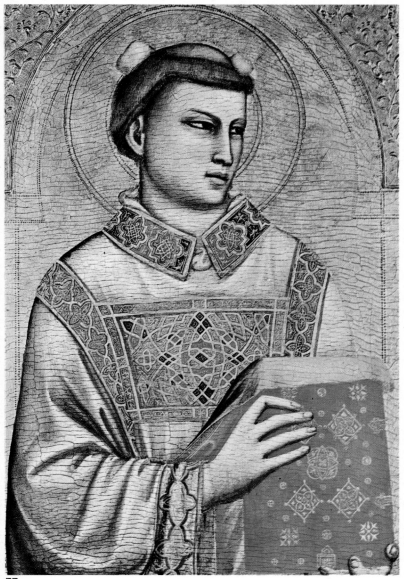

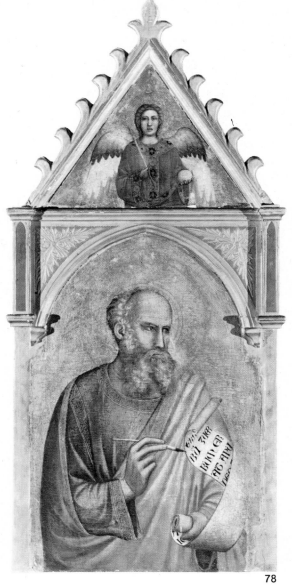

78

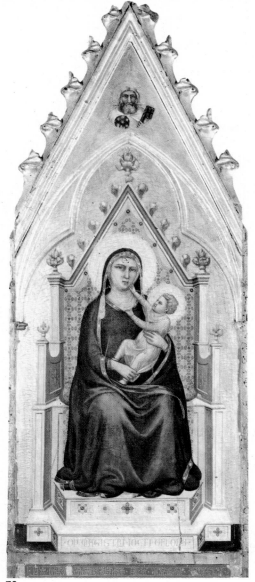

79

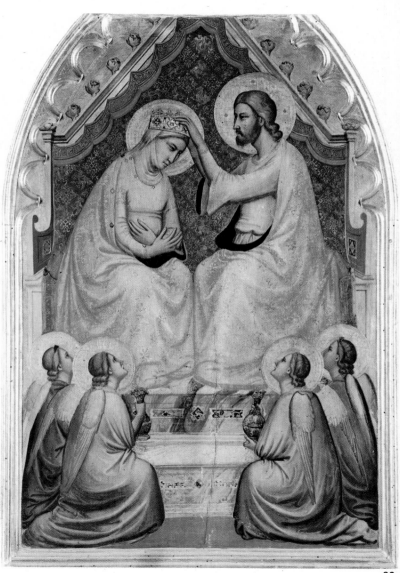

80

DOLPHIN ART BOOKS · 80 COLOUR PLATES

An attractively priced library of monographs dedicated to presenting the work of the greatest painters, sculptors and architects of all time. Each volume, based on the latest research, is written by a leading authority, and contains a biography, a critical appraisal of the work, and fully documented notes on each plate.

GIOTTO

The first outstanding creative figure in Western painting, Giotto was also one of the few artists whose revolutionary achievements have been recognized and praised in their own time. After the stereotyped forms, and the flat, pattern-like, Byzantine manner of previous Italian painting, the three-dimensional solidity of Giotto's compositions, the individuality of his figures, and the dramatic realism of his scenes, were a revelation to his contemporaries. In his great series of frescoes (above all, those in the Arena Chapel, Padua, *c.* 1305) mankind is for the first time allotted the dominant place, nobly at ease in a world where even the most ordinary, everyday things are depicted with fervent naturalism. It was this passionate humanism that was to be the theme of Renaissance art — and, indeed, of all Italian art down to Tiepolo.

THAMES AND HUDSON

ISBN 0-500-41015-1 NBZI

Printed in Italy

9 780500 410158

MICHELANGELO: PAINTING

The life and work of the artist illustrated with
30 COLOUR PLATES

LUCIANO BELLOSI

A DOLPHIN ART BOOK

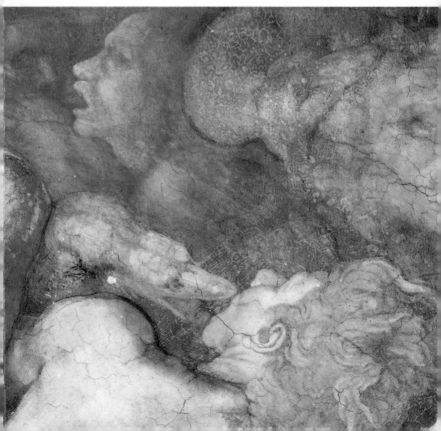